the Crafty Chica Creates!

KATHY CANO-MURILLO
The Crafty Chica

the Crafty Chica Creates!

Latinx-Inspired DIY Projects
with **Spirit** and **Sparkle**

QUARRY

First Published in 2021 by Quarry Books, an imprint of The Quarto Group, 100 Cummings Center, Suite 265-D, Beverly, MA 01915, USA.

T (978) 282-9590 F (978) 283-2742 QuartoKnows.com

Quarry Books titles are also available at discount for retail, wholesale, promotional, and bulk purchase. For details, contact the Special Sales Manager by email at specialsales@quarto.com or by mail at The Quarto Group, Attn: Special Sales Manager, 100 Cummings Center, Suite 265-D, Beverly, MA 01915, USA.

10 9 8 7 6 5 4 3 2 1
ISBN: 978-0-7603-7218-0
Digital edition published in 2021
eISBN: 978-0-76037-219-7

Library of Congress Control Number: 2021943337

Design and Layout: Laura McFadden Design, Inc.
Photography: Genaro Delgadillo, @genaro214, , except page 14 (Shutterstock.com); and Bobbie Bush Photography, www.bobbiebush.com / Saunders Photography, pages 9 top row & bottom right, 36, 37, 40, 41, 43 top, 47, 56, 63, 64, 67 bottom, 68, 71, 74, 83, 89, 93, 94, 103, 106, 107, 111, 115

Printed in China

This book is dedicated to
all the crafty chicas out there.
You know who you are!
May you all continue to create
and share your talent and love.

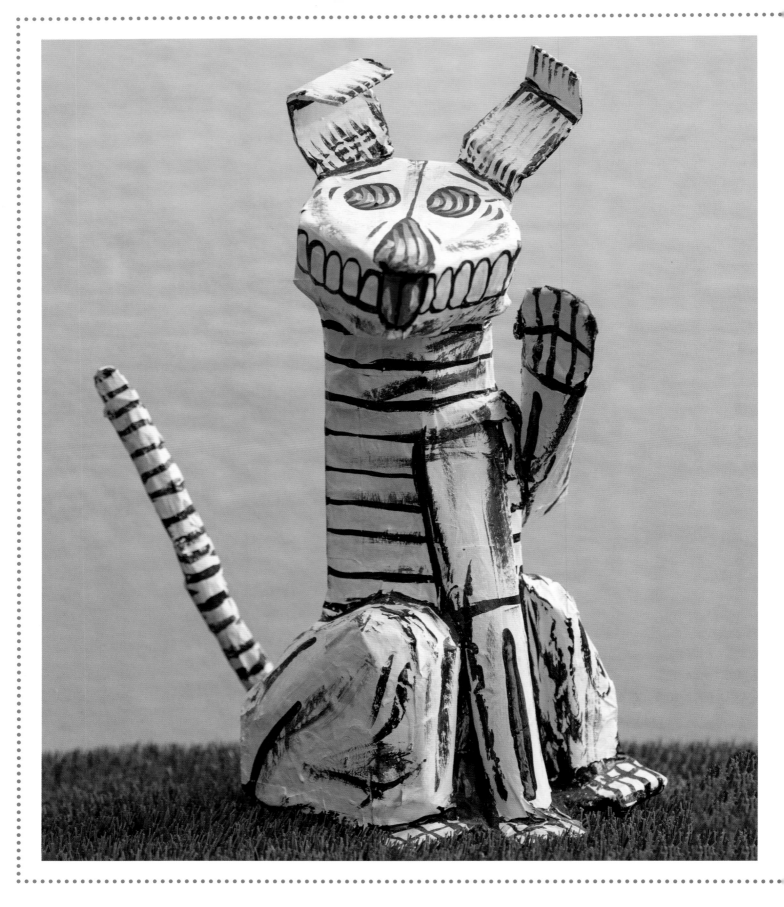

Contents

Introduction

Let's do this!

Welcome to *The Crafty Chica Creates!* It's been twenty years since I launched my brand, Crafty Chica. I had no idea that celebrating my Mexican-American culture via glue and glitter would lead to a thriving career of creativity, but here we are!

This book is a personal invitation into my world of making and affirmational thinking. The magic of these projects comes from not just the design, but also the intention you put into them. Some past favorites are included, plus a whole new collection.

Whether you're an expert or a novice, join me on this journey. I'm your workshop teacher, leading you through each project and the purpose behind it. All these ideas touch on a range of techniques and themes, but each is meant to bring magic to your creative spirit.

Mexican music and munchies are not required, but they help keep the mood festive!

I created these DIYs to brighten your living space and bring good energy, all with a splash of Latina spirit. They'll pep up your décor and your mood, too!

You can use these projects for:

· Decorating your *casa* or workspace
· Group crafting with family and friends
· Improving your mental health, easing tension, and destressing
· Affirmations to lift your mood and/or attitude
· Developing your crafting skills
· Gift giving

As you work on each project, you can choose to make it as is or be innovative and add your own twist. You'll find ideas to use beloved Latino-centric novelties in unexpected ways.

I hope you're excited about what lies ahead. Now, let's get crafting!

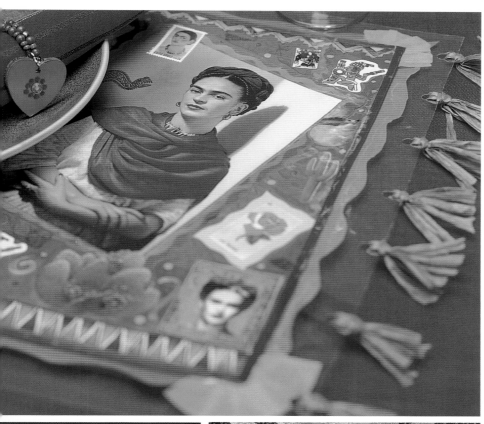

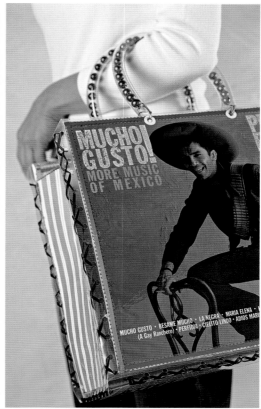

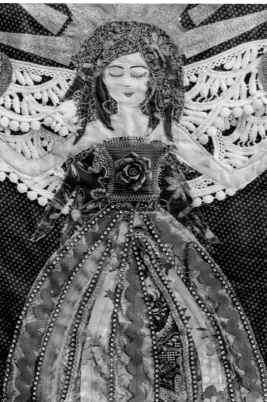

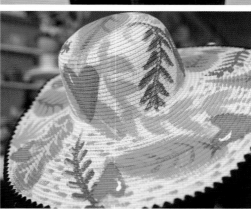

1

What Is Latin Style, Anyway?

How can one accurately define Latin style? Before visions of a man sleeping in a sombrero sitting by a cactus or a string of chili pepper lights pop in your head, read on. Those stereotypes are everything Latin style is not.

Latin style is diverse.

The term "Latin" is as vast as a global food buffet. Before you reach for an artsy antacid, relax. This book keeps it simple. These are projects I dreamed up that celebrate my personality and cultural background. My point of view is that of a third-generation Mexican-American Gen-Xer. There are many others like me

who can relate. But I've also discovered there are many others who have a completely different perspective and style from mine. All are completely valid, worthy, and authentic.

That's why I always tell people to make these creations so they represent *your* story, incorporating your personality as much as possible. Not only will these become your legacy crafts, but you might just discover something new about yourself.

My biggest inspirations are the homes in the Southwest region of the United States. Using Mexico and Spain as the inspirational foundation, these houses

have walls that sport stucco or faux finishes in rich, bold tones and are trimmed with Talavera tiles. The floors are lined with either Saltillo tile or painted concrete. The furnishings are chunky and oversized, and the accent pieces include painted tin candlesticks, coconut masks, wood-block prints, red clay patio chimneys, and bright baskets. The tones range from earthy to glossy and contemporary to primitive.

But that's just one version. Traveling through Mexico, I've found minimalist décor with light touches of color and metal. There is no right or wrong. It's all about the story you want to tell.

No matter what aspect of Latino life lights your fire, there are ways to harness it for an expressive twenty-first century art form.

One example is the ancient Aztec calendar. It was created centuries ago as a means of foretelling the future. These days, the intricate circular design is used for concrete wall hangings, stylish empowering T-shirt, jewelry pieces, and even company logos.

Latin style is a gregarious way of living that is woven, painted, carved, sketched, punched, sewn, and chiseled every minute into holidays, meals, and family gatherings. Think hot hues on floor rugs or party favors, scrumptious serving dishes embellished with searing chilies, centerpieces layered with ornate hand-punched tin, and rows upon rows of *papel picado* (Mexican paper cut) banners hanging from the ceiling. Whether a solo piece or an outlandish combo, they are all apart of the fiesta family.

But that's just my perception of Latin style that I call Mexi-boho.

What's yours?

Mexican Pop Art

Latin style isn't only about tossing a *serape* on top of the couch. It also thrives on originality—converting the *serape* into fringed throw pillows and *then* tossing them on the couch. Welcome to the campy world that is known as pop art. This approach stems from turning everyday objects that are commonly taken for granted into lively accessories.

Consider a tongue-in-cheek method of making fun, functional art out of ordinary objects. Mexican pop art's subjects include historical icons, beloved Latin food labels, children's games, religious saints, and food containers. Some of the most beloved subjects used in Latin pop art are the legendary Mexican painters Frida Kahlo and Diego Rivera, the mighty *Lucha Libre* wrestlers, *Día de los Muertos* skeletons, and the sacred image of the Virgin of Guadalupe.

These tangible topics are respectfully reinvented for the sake of décor and accessories: handbags, bottle cap crucifixes, picture frames, and furniture. Even if your only experience with Latin culture is Taco Tuesday, there are plenty of ways to bring the wonderful genre of Latin style into your home and life!

2

Materials and Techniques

Just because your colorful ideas are doing some fancy mambo steps doesn't mean your organizational skills can join in. *La casa loca* may be happy, but *la workspace loca* can cause a crafting hangover. Consider this chapter the outlined diagram to doing the creativity cha-cha.

Getting Started

Adapt a healthy mindset. *Inhala, exhala* . . . remember, this is about having fun, expressing yourself, and creating one-of-a-kind pieces. Practice makes progress. There are no hard-line rules; creativity is about exploration and expression!

Begin by collecting an array of Latin-themed items to use in your projects: postcards, food labels, postage stamps, fabric scraps, stickers, bottle caps, phone cards, magazines, and small toys. These can be found at swap meets, grocery stores, flea markets, thrift boutiques, and museum stores. If all else fails, sign on, search the web, and surf your way to online auctions.

Keep in mind that you shouldn't use licensed images in artwork you intend to sell. If you use images from another artist, even for personal use, make sure to ask them for permission. The goal is to have good vibes and honor each other's space, talent, and business. I've provided some images and patterns at the back of the book for your personal use.

Basic Materials

Some of the supplies you'll need can be found at craft, fabric, home improvement stores, and even online. Here's a general rundown of materials used in these projects, but keep in mind that a materials list is a lot like an afternoon fiesta—the more the merrier. Don't feel overwhelmed if you don't have all the resources or equipment listed; you can always make substitutions or use an alternate method. That's all part of creating art—making it your own!

- Paints—craft paints both acrylic and enamel, satin finish spray paint, brush-on fabric paint, sheer glitter fabric paint, dimensional fabric paint, and alcohol inks

- Pencils, markers, ballpoint pens, acrylic paint markers, wood stain markers, and disappearing ink pen or tailor's chalk

- Rubber stamps or cling stamps, ink pads, stencils, and alphabet letter stickers

- Papers in different textures, weights, and designs, stationary, cardstock, crepe paper, postcards, magazines, comic books, and tracing paper

- Fabrics, Mexican oilcloth, fabric trims, fringe, lace, felt and felt letters, appliques, buttons, polyester fiber fill pillow stuffing, and an iron and ironing board

- Air-bake and oven-bake clay, whipped clay and piping tips, clay roller, and plaster wrap

- Sewing thread, embroidery thread, embroidery hoop, sewing and embroidery needles, yarn, crochet hook, ribbon, straight pins, and rotary cutter

- Tape measure and ruler

- Tapes—clear, masking, painter's, duct, washi tape, and electrical

- Paintbrushes—in assorted shapes and sizes including flat shader, large round, thin liner, soft bristle, and foam craft brushes

- Glue and adhesives—hot glue gun and hot glue sticks, white craft glue, industrial-strength craft glue, washable permanent fabric glue, glitter glue, extra-strength waterproof

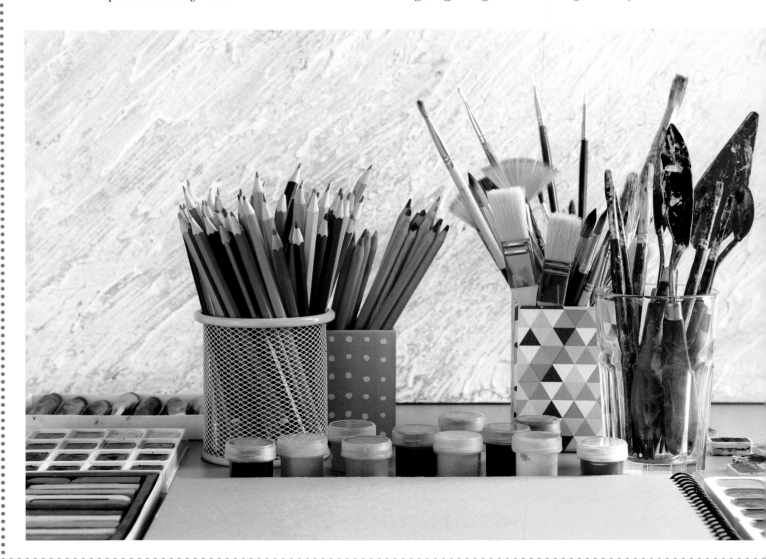

glue, glue sticks, spray adhesive, and double-sided extra-strength dry adhesive sheets

· Varnishes and sealers—high-gloss and matte brush-on polyurethane spray varnish, high-gloss and matte water-based polyurethane brush-on varnish, water-based glitter, and Glitter Mod Podge

· Jewelry making supplies—jump rings, head and eye pins, earring hooks, and hair combs

· Tools—camera or smartphone and printer; craft knife with assorted blades and cutting mat, basic scissors and decorative edge scissors, staple gun and staples, sandpaper, hammer, screwdriver, needle-nose pliers, tweezers, hole punch, and can opener; power drill; clay, tin, and woodworking tools; and wood-burning utensil

· Fasteners—wire, jute rope, string, hinges, screws, skewers, toothpicks, floral foam, craft foam, hole-punch reinforcements, and sawtooth picture hangers
· Embellishments: seed beads, craft beads, charms, rhinestones, crystals, craft gems, glitter, sequins, and gold tacks

· Accessories and found objects: tassels, plastic and dried flowers, Mardi Gras beads, raffia, straw, mirrors, wood cutouts, small toys, stamps, coins, trinkets, glass pebbles, rocks, and bottlecaps

· Optional—sewing machine, embossing stylus set, heat gun, jigsaw; electronic cutting machine with vinyl sheets, transfer tape, and burnishing tool; and home spiral bookbinding tool and accessories

Tips and Tricks

· Clear an area large enough to allow for bursts of creativity and easy assembly.

· Store small items in plastic segmented trays or plastic sandwich bags.

· Always sketch out designs before committing to them in your final work.
· Adding a dollop of industrial-strength craft glue will help heavy objects set quickly. Add glue to the center of the area and surround the edges with hot glue. This technique holds the item in place until the glue cures.

· Make color copies of photos that you don't want to permanently attach to your work.

· Add a protective sheen to photocopies and other images by first brushing on a thin layer of white craft glue. Let the glue dry and then varnish as usual. Don't varnish without sealing the image first or the varnish will seep though and ruin the picture.

· Be safe. Always use gloves, a mask, and goggles for projects that incorporate sharp tools or airborne fumes. Always follow the manufacturer's instructions when working with materials or tools.

These art pieces are supposed to induce smiles. Keep up the momentum by grooving to Latin tunes while you work. I curated a playlist for you; visit the Crafty Chica Spotify playlist to hear!

3

Clothing

Wear your style loud and proud!

I learned this when I had the incredible opportunity to walk the red carpet for the world premiere of the Disney-Pixar movie *Coco*.

I was invited to attend the event along with two dozen other bloggers. We were to mingle among the cast, the press, and movie industry executives to celebrate the debut of the film at the El Capitan Theater in Los Angeles. "Pull together a Hollywood-worthy outfit," they told us.

OMG. My first thought was to trick out a jeans jacket in full *Día de los Muertos* style. I painted it, added sequins, gems, trim, and embroidery, and it served as a visual representation of my passion for all things *Coco*. I choose a red maxi dress to wear underneath and a pair of sequined flats.

I couldn't contain my excitement as we got on the bus to go to the event. False lashes, glitter green eyeshadow, and floral headdress in place, I hustled out front—only to see the other bloggers in serious high-glamor outfits: stiletto heels, dripping jewels, and shimmery gowns that draped perfectly over their respective bodies. And there I was: Kathy, the Crafty Chica, sporting a kitschy hand-painted, rhinestone-encrusted jeans jacket.

I began to tremble. I wanted to return to my hotel room for the night. I felt so stupid and humiliated. How could I not understand what Hollywood red carpet attire meant? But my enthusiasm had taken over. So, what happened?

Just as I stood up to leave, my friend turned to me and said, "You look so beautiful, Kathy. You are going to have the best night of your life!" My heart tingled. My guardian angel swooped in to give me the encouragement I needed to move forward. I shakily inhaled and decided to stay.

Wouldn't you know—photographers asked *me* to pose with my amazing jacket. All through the night, guests stopped to take pictures and showered me with compliments. It turned out to be one the best nights of my life.

Be proud of your personality and your original style. This is our one life to shine and make our mark. Please don't ever dim your brightness in order to fit in. Just do you. You are worth it and the world really needs your authentic self.

I hope you enjoy these clothing projects, and I hope they inspire you to make them as is or with your own flare.

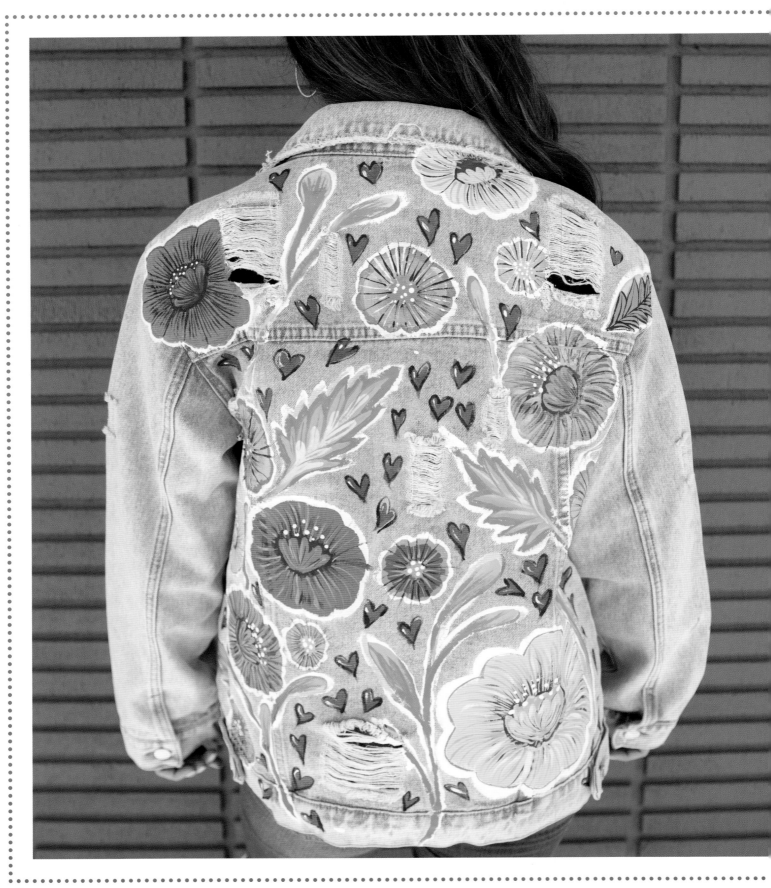

Las florecitas painted jacket

Find a jacket, any jacket. It can be old or new because you're going to give it a makeover worthy of *mucho* admiration! Check out thrift stores or second-hand stores for unique jackets, or rummage through your closet to find the perfect wearable canvas.

Makes one jacket

materials

Denim jacket or other kind of jacket of choice

Camera or smart phone and printer

Paper and pencil

Disappearing ink pen

Brush-on fabric paint in assorted colors

Sheer glitter fabric paint

Assorted paintbrushes

Embellishments, such as trim, embroidery, or crystals

1. Take a picture of the back of your jacket and print it onto a piece of paper.

2. Sketch a design onto the paper using a pencil. I drew large, bold flowers and leaves and small hearts on the back of the jacket. You can also use an illustration app such Procreate to build your design.

3. Once the design is done use a disappearing ink pen, or tailor's chalk, to draw it onto the jacket. Don't worry about staying within the seam lines—let your creation flow all across the back, arms, and the bottom of the jacket.

4. Paint a thin layer of white fabric paint within the sketched designs. This will make the colors pop. Allow the white paint to dry thoroughly.

5. Use a round brush to fill in each design's background color. For a Mexican oilcloth-inspired look like this, leave a white halo around the motifs and then add accents of yellow and blue.

6. Add a second layer of color to your motifs, which should be a lighter shade than the background. Allow the paint to dry.

7. Use a liner brush and black or white paint to create accents and details such as lines, dashes, or dots. Allow the paint to dry. To incorporate some shine, add a layer of sheer glitter fabric paint. Allow that to dry.

8. Embellish the jacket further if desired by adding trim, embroidery, or crystals.

Muy fantastico shirt hack

The next time you clean your closet, look for shirts you can cut up and combine to make new garments. Not only does this cut down on textile waste, but you'll end up with some super cool garments to wear, share, or even sell.

That is the spirit of this project. I aimed to purge my wardrobe but didn't want to give away or toss out some of my favorite pieces. My closet-cleaning mission became a two-day crafting session resulting in several upcycled shirts that I sold in my Phoenix boutique. Guess what I used my profits for? Upgrading my closet organization!

Makes one shirt

materials

- Button-front shirt, washed, dried, and ironed
- Cutting mat
- T-shirt with a design that can be repurposed
- Fringe or trim
- Buttons or appliques (optional)
- Sewing machine, cotton sewing and thread needle, or washable permanent fabric glue
- Straight pins
- Scissors, pinking shears, or rotary cutter
- Ruler or tape measure

1. Lay the t-shirt flat on a cutting mat. Use a rotary cutter or pinking shears to cut out the design you want to use for the back of the shirt.

2. Pin the t-shirt piece in place on the back of the shirt. Sew in place by machine or hand stitch using a whip stitch.

3. Measure the t-shirt piece and cut trim to fit. Pin the trim in place and stitch to secure using a running stitch. Alternatively, secure the trim with fabric glue.

4. Add extra accents as desired, such as more trim and applique, or sew on buttons.

5. As an option, embellish the front of the shirt as well.

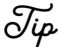

Tip Here are more ideas to make your shirt unique:
- Choose a theme for your shirt and coordinate the details to match.
- Add accents with fabric paint. Place a piece of cardboard underneath one layer of the shirt before painting so the paint doesn't seep through the fabric.

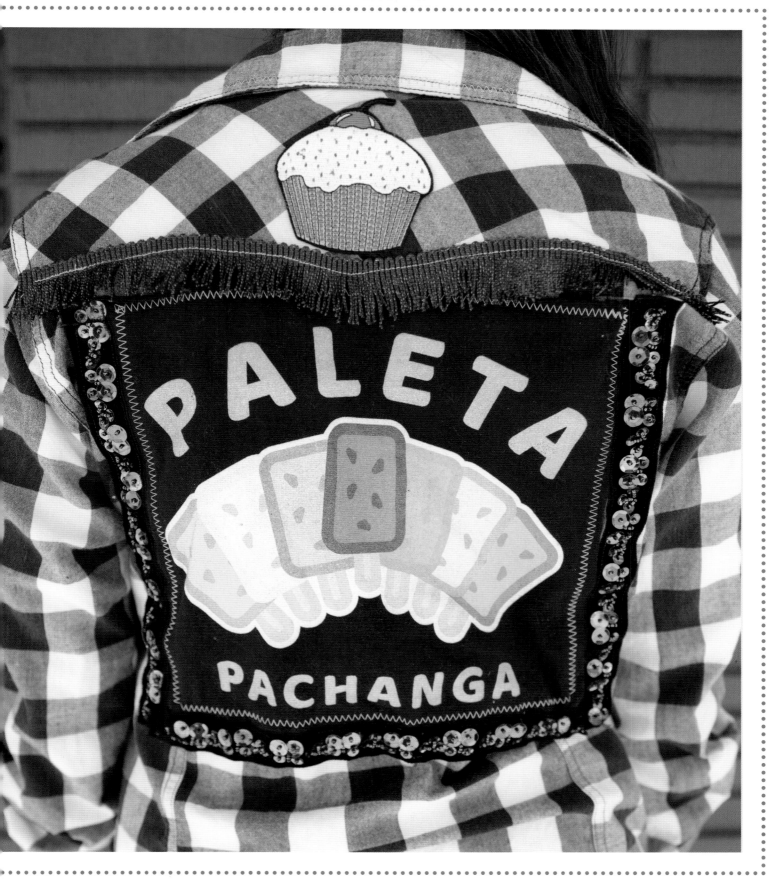

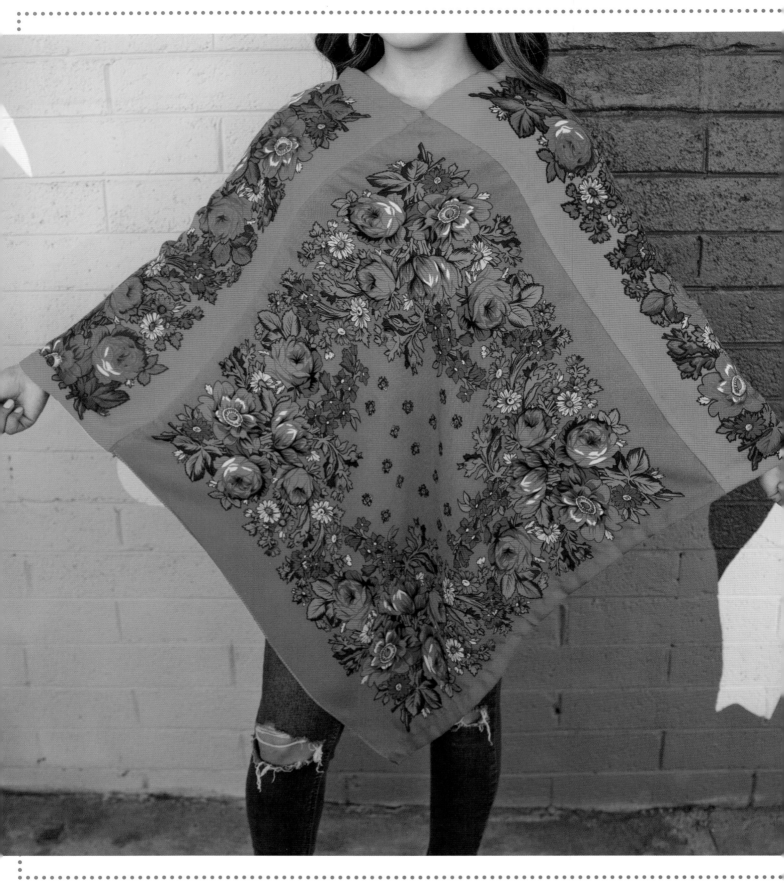

Preciosa scarf poncho

Don't you love jumbo floral scarves? Worn around your neck or shoulders or even tied around a purse, they add a touch of drama. You can even sew two together to make a pillow cover.

Here's another idea: Make a scarf into a poncho! I used three matching square scarves to make this vibrant coverup, but you can also use different colors and patterns for a patchwork-style look.

Makes one scarf poncho

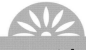

materials

3 square scarves,
30" x 30" (76 cm x 76 cm)

Scissors

Ruler or tape measure

Sewing machine or cotton sewing thread and needle

Straight pins or clips

Iron and ironing board

1. Iron the scarves to remove any wrinkles.

2. Pin the three scarves together along one edge, right sides together. Stitch the pieces with a 1" (2.5 cm) seam allowance using a running stitch, so that the finished piece measures approximately 86" (218.5 cm) long.

3. Press the seams open.

4. Measure, fold, and pin a 1¹/₂" (4 cm) hem along both long sides of the piece, so the width measures approximately 27" (68.5 cm). Stitch the hem by hand or use a sewing machine and press.

5. Fold the piece in half widthwise and cut up the center. You will now have two halves.

6. Hem, pin, and sew the raw edges together using a whip stitch. This will hide the raw edge where you cut. Press.

7. Take one piece and place it right-side up, horizontally.

8. Take the other piece and place it right-side down, vertically, so it lines up with the top left corner of the other piece. It should look like an upside-down capital L.

9. Pin the top edge, only to where the two ends meet, about 43" (109 cm) in.

10. **On the top piece of fabric:** Put your finger where your seam ends (where you just finished sewing). Now, move your finger down to where the two ends meet at the bottom; again, we're on the top piece of fabric.

11. Pick up that spot on the top piece and use your other hand to pick up the bottom-right corner of the same top piece.

12. Lift and place this top piece and pull it up and over to the right to match with the width end of the bottom piece of fabric.

13. Pin or clip in place and sew up that side.

14. Press.

15. Cut any loose threads.

16. Turn your poncho so the right side is facing out.

materials

Black circle skirt

Camera or smart phone and printer

Assorted appliques (To duplicate this project, you will need an applique of The Virgin of Guadalupe, butterflies, and various flowers. If creating your own design, you will need to choose appropriate appliques for your desired pattern.)

Paper and pencil

Cotton sewing thread and needle or washable permanent fabric glue

Straight pins

La bonita applique skirt

There comes a time when a *chica* just wants to be extra. That's when a skirt like this is needed. The Virgin of Guadalupe represents love, hope, beauty, and strength—but most of all, the divine female spirit.

This project is inspired by the gorgeous painted velvet skirts of Mexico. You can choose to hand paint a design on a skirt or use appliques as I've done here. Either way, you'll have an artful garment.

Makes one skirt

1. Sort the appliques by size.
2. Place the skirt on a flat surface and fan it out.
3. Take a top-down photo, also called a flat lay, and print it or import it to an illustration app such as Procreate.
4. Sketch the design and placement of the appliques on the skirt as a guideline.
5. Place the appliques in the pre-arranged design. I started with the Virgin of Guadalupe in the center and placed rose appliques around the main motif and along the bottom of the skirt.
6. Once the appliques are in place, take a top-down photo to check the balance of the pieces. Adjust them as necessary.
7. Pin the appliques in place and hand sew them to the skirt using a running stitch or a whip stitch, or adhere them with fabric glue.

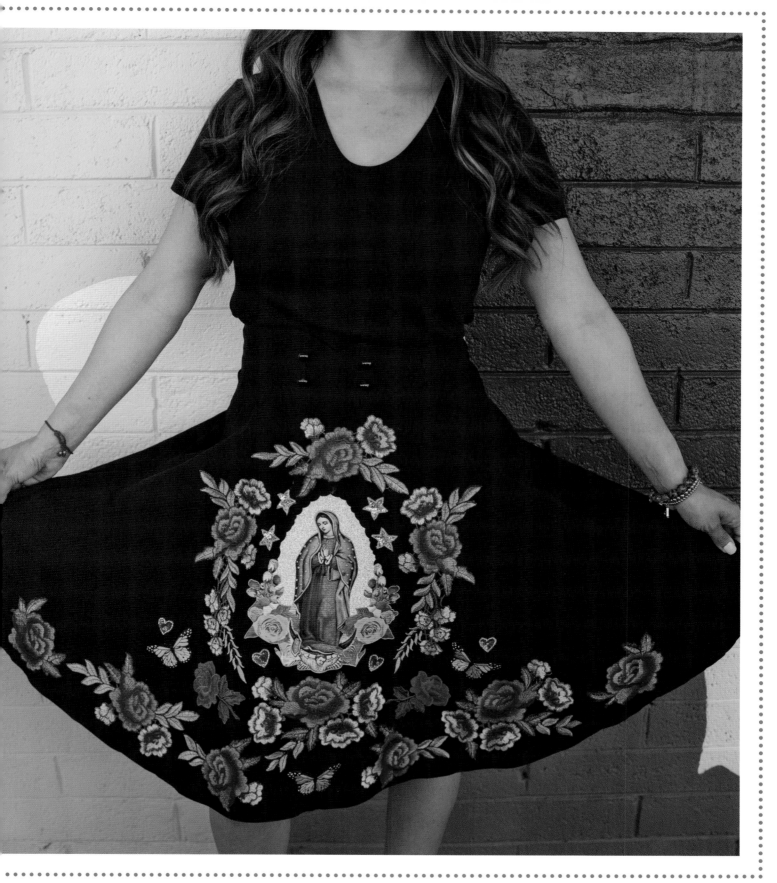

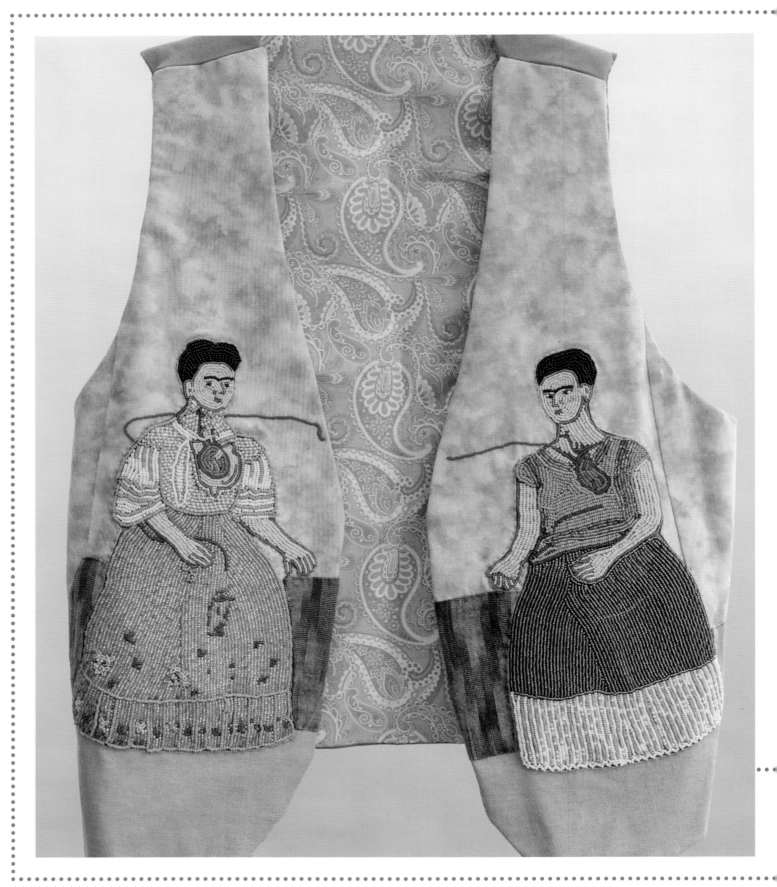

The two Fridas beaded vest

If you love the artist Frida Kahlo, you'll appreciate this project. In 2004, I founded The Phoenix Fridas, a Latina art collective in my hometown of Phoenix, Arizona. Each member of the group is an artsy superhero of creativity and inspired by Frida in some way. This vest was created by two Phoenix Frida members, Anita Mabante-Leach and Gloria Casillas Martinez.

They worked together to craft a design in a fine art spirit. Anita used a pattern to make the vest and chose the inner and outer fabrics, which were Frida inspired. Gloria worked her seed bead magic to fill in the Fridas.

Frida was complex with her emotions and artwork, and Gloria captured that essence with her delicate beadwork. Special thanks to Gloria and Anita for sharing this project with all of us!

Makes one vest

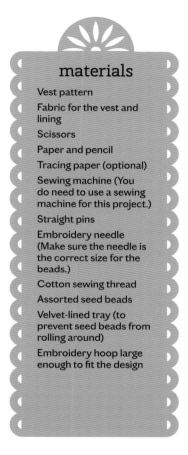

materials

- Vest pattern
- Fabric for the vest and lining
- Scissors
- Paper and pencil
- Tracing paper (optional)
- Sewing machine (You do need to use a sewing machine for this project.)
- Straight pins
- Embroidery needle (Make sure the needle is the correct size for the beads.)
- Cotton sewing thread
- Assorted seed beads
- Velvet-lined tray (to prevent seed beads from rolling around)
- Embroidery hoop large enough to fit the design

1. Cut the pattern pieces of the vest. Before sewing the front and back, draw the outline of your design onto the front piece. You can also trace the outline onto the fabric using tracing paper.

2. Create a sketch to determine where to apply the various colors of seed beads.

3. Place the embroidery hoop on the top pattern piece fabric, around the design.

4. Cut a piece of sewing thread approximately 12" (30.5 cm) and thread the needle, doubling the thread and knotting it at the end.

5. Bring the needle through the fabric from the back and go into the fabric from the front, creating a small stitch. This will help secure the beadwork. Bring the needle through the fabric from the back again, in the same spot, and pick up one bead with the needle. Push the bead down until it's flushed with the fabric.

6. Lay the bead sideways on the fabric and insert the needle down through, securing the bead. Repeat, attaching one bead at a time, going in rows, until each space is filled and the design is complete.

7. Finish sewing the vest according to the pattern instructions.

Tip Creating a large, detailed design is a serious undertaking, but you can speed the process by using a Frida-inspired or themed fabric and sewing beads in some areas of the design.

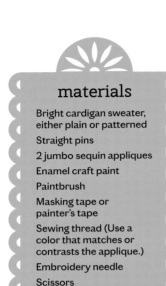

materials

Bright cardigan sweater, either plain or patterned

Straight pins

2 jumbo sequin appliques

Enamel craft paint

Paintbrush

Masking tape or painter's tape

Sewing thread (Use a color that matches or contrasts the applique.)

Embroidery needle

Scissors

El sol cactus sequin sweater

This upcycled sweater is perfect for when it's cold outside, but you want to manifest warmer weather. Find the brightest, sunny yellow sweater you can, and one with polka dots is even better. Trust me, you'll know the perfect one when you see it!

You can find an array of sequin appliques online or in craft, hobby, or import stores. This sweater showcases a saguaro and a prickly pear cactus, but many more designs are available, including sacred hearts, Aztec designs, Frida Kahlo portraits, and animals.

Makes one sweater

1. Decide where you want to place the sequin appliques on the sweater. I used large cactus designs and anchored them at the bottom, but try them at the top or across the front on a diagonal. Pin them in place.

2. Cut a 24" (61 cm) piece of sewing thread, double thread the needle, and tie a knot at the end, leaving a small tail.

3. Insert the needle from the underside of the sweater and through the edge of the applique.

4. Use a running stitch or a whip stitch to secure the applique around the border. If you run out of thread, insert the needle into the fabric from the front, knot it on the back, and cut. Repeat the threading and sewing process until the applique is secure.

5. Use enamel paint to add color to the buttons. To prevent paint spillage, use pieces of masking tape or painter's tape around and under the buttons.

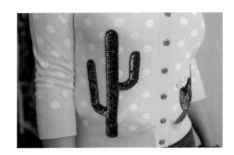

 Tip Alternatively, you can use washable permanent fabric glue to attach the appliques to the sweater. Insert a piece of parchment paper inside the sweater while gluing to make sure the glue doesn't seep onto other areas of the sweater.

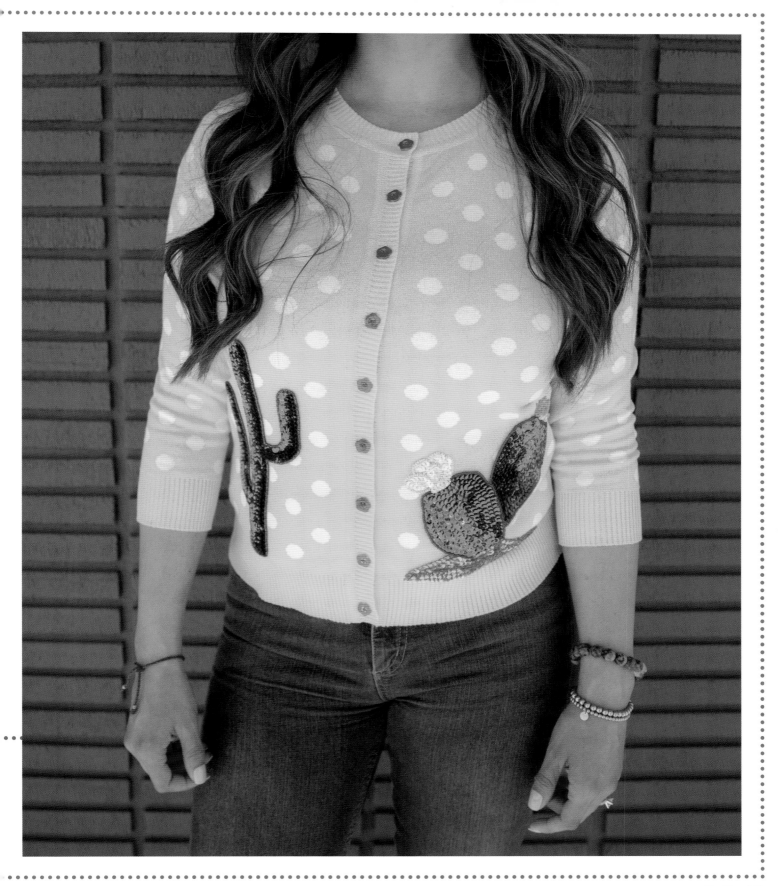

4

Artful Affirmations

Affirmations are crucial for a healthy mindset. It's so easy to feel overwhelmed or anxious about the future, projects to tackle, or even the daily routine of life. By organically weaving in uplifting thoughts and actions, you can learn to embrace self-love, forgiveness, and confidence.

I wanted to be a painter or illustrator early in my crafty career. I attempted to paint canvas art so many times, but I couldn't even produce a decent doodle! Do you know the feeling when you have expectations, but your hands can't deliver? Because of that, I used to feel bad about myself and I even wanted to give up.

But instead, I kept painting, researching, practicing, and taking workshops over the years, working hard to sharpen my skills. The most significant changes came when I wrote and read affirmations to myself daily as a reminder to stay focused and always picture the end result.

I'm so glad I did that because I pulled out all my wonky paintings, imported them into the Procreate app, and redrew the faces with all the new skills I acquired. Now, I have a national greeting card line and fabric collections based on that transformed artwork. Art never has an end point; you can always continue to rework, recreate, and evolve your creations. In fact, your story is even richer when you show your growth!

Here are affirmations you can use in your daily life when working on your art and craft projects:

- I am a creative person and I love coming up with new ideas.
- Plenty of room exists in my community and in the world for me to share what I've made.
- I'm excited to keep practicing so I can get better and better.
- Inspiration is everywhere; I just have to be open to receiving it.
- I have everything I need to be creative. All I have to do is apply myself.
- My work's value is represented by my love and uniqueness, not by money.
- I love to support other creatives and see us grow together in our artful lives.

Are you ready? Here are some project ideas you can do for yourself or with friends!

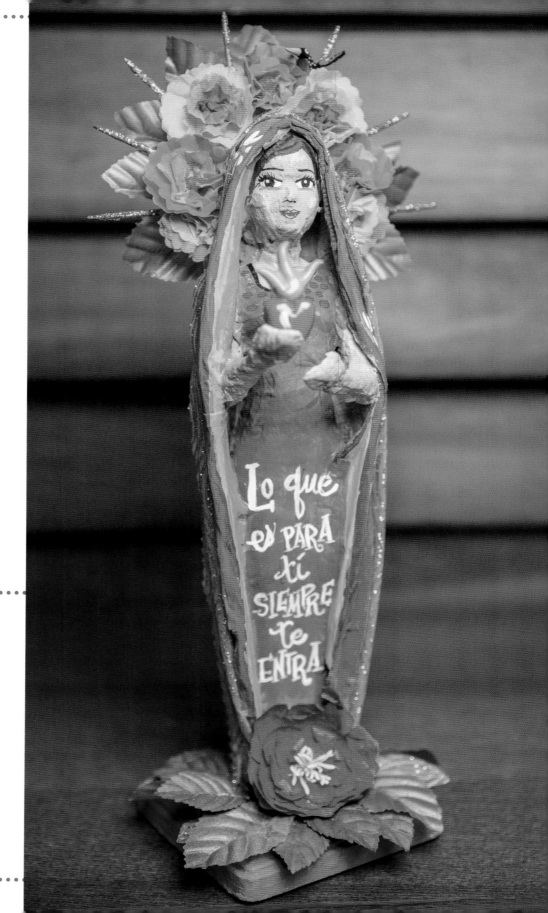

Tip

You can use the doll as is without wrapping it in plaster strips. Simply drape the body with fabric and textiles. I like the plaster wrap because it looks more like a statue. You can also try this technique to create *Día de los Muertos* figures.

La diosa empowerment guardian

Do you ever feel like you need a spiritual cheerleader? Enter *la diosa*, the goddess. Take some time to craft your own personal empowerment guardian to remind you how awesome, loved, and protected you are.

La diosa is more about self-empowerment. She's there to help you channel your inner bohemian goddess!

Makes one statue

1. Create a structure for the doll to stand securely on the wood base. Turn the doll upside down and drill a hole at the center-bottom of her torso large enough to accommodate the wire hanger piece.

2. Drill a same-size hole in the base, about 2" (5 cm) of the way through.

3. Insert one end of the wire into the hole in the doll and the other into the base.

4. Secure the doll by using hot glue to adhere her feet to the base. Affix hot glue to the area where the wire meets the base as well.

5. To create bent arms on the doll (this is helpful if you want it to look as if it's holding something), cut the arms at the elbows with scissors and hot glue them in the desired position.

6. Create a halo by attaching the back of the doll's head to the small wood circle with hot glue.

7. Cut about 24 strips of plaster wrap into 2" x 1" (5 cm x 2.5 cm) pieces. Dip each piece in water and place them on the doll. Cover the entire body, plus the hair, halo, hands, and face. Use your fingers or a damp sponge to smooth out the wrap. Let dry completely overnight.

8. Paint the entire doll as desired. I painted a dress with an inspirational quote. Add fabric or trim if desired; I created a long veil that covered her head and body. Decorate the halo with the flowers, leaves, and glittered toothpicks.

9. Add additional leaves and flowers to the base.

10. You can also attach an embellishment to the doll's hands, such as a secret note, a heart, or a rose, with hot glue, if you'd like.

materials

- Fashion doll, about 11" to 12" (28 cm to 30.5 cm) high
- Wood base, 5" (13 cm)
- Power drill
- Clothes hanger wire piece, 4" (10 cm) long
- Plaster wrap
- Water
- Kitchen sponge
- Acrylic craft paint in assorted colors
- Assorted paintbrushes
- Fabric or trim
- Lightweight wood circle to serve as the doll's halo or crown, 3" (7.5 cm)
- Toothpicks covered with glitter
- Small flowers and leaves
- Hot glue gun and hot glue sticks
- Scissors

Embellishments: miniature written note, small heart bead, or small faux rose (optional)

Repujado dicho matchboxes

These are the cutest matchboxes ever! While they look like regular matchboxes on the outside, each has a *dicho*, a saying or proverb, inside.

Matchboxes make great party favors, so you'll love creating and sharing these. Use the template (see page 118) or make your own design. Write fortunes to include inside the boxes or commemorate a birthday, holiday, or memorial with quotes from family or friends. These are uplifting gifts and handing them out feels good.

Use photos, illustrations, scrapbook paper, or hand-painted designs to decorate the outside of the boxes. I used a technique called *repujado en aluminario*, or embossed aluminum.

Number of matchboxes will vary

materials

- Small matchboxes
- Glass jar or tin can to store matches
- Soda can, washed and dried
- Tin snips
- Safety gloves
- Sandpaper or emery board
- Glue stick
- Hot glue gun and hot glue sticks
- Acrylic craft paint in assorted colors
- Assorted paintbrushes
- Printed *dichos* (See template on page 118.)
- Alcohol inks
- Craft foam, 5" x 7" (13 cm x 18 cm)
- Embossing stylus set (optional)
- Ballpoint pen
- Water-based polyurethane brush-on varnish, your choice of matte or gloss
- Single sheet of aluminum

1. Empty the matchboxes and place the matches in a glass jar or tin can.

2. Paint the inner sleeve and the sides and back of each matchbox with vibrant acrylic paint colors. Let dry.

3. Adhere the *dichos* to the inside of the sleeve with a glue stick.

4. Add painted accents. I painted dots and dashes. Allow the paint to dry thoroughly and coat the boxes with water-based varnish. Allow the varnish to dry.

5. While wearing safety gloves, cut off the top and bottom of the soda can with tin snips. Cut up the side of

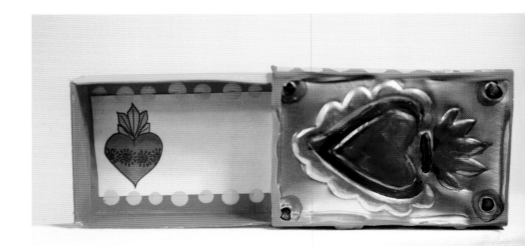

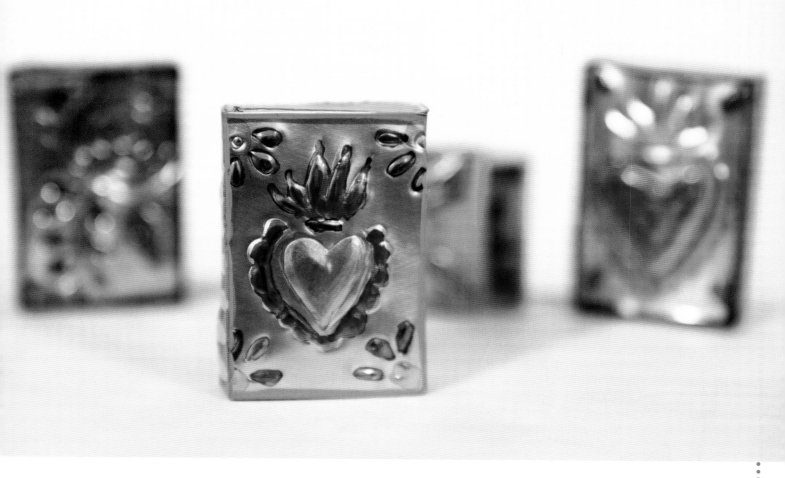

the can to create a single sheet of aluminum. Cut the aluminum to the size of the matchbox cover.

6. File the edges and corners of the aluminum with sandpaper or an emery board until they're no longer sharp.

7. Place the aluminum piece printed-side down on the craft foam. Draw a loose design (not too much detail if you are a newbie) with a ballpoint pen or thin embossing stylus, pressing hard so the lines are deeply recessed. I created sacred heart designs.

8. Flip the aluminum piece over and use a round embossing tool on the areas within the lines you drew to make them pop out.

9. Flip the piece over again and continue working on both sides until you're happy with the embossing. The blank side, which is the finished side, should be protruding out.

10. Place the printed side of the aluminum piece face up and use hot glue to fill the recesses. While the glue is still wet, quickly place the piece on the matchbox. Glue down all the edges with hot glue until the piece is secure.

11. Use alcohol inks and a small paintbrush to add color to the tin, following the manufacturer's instructions for application.

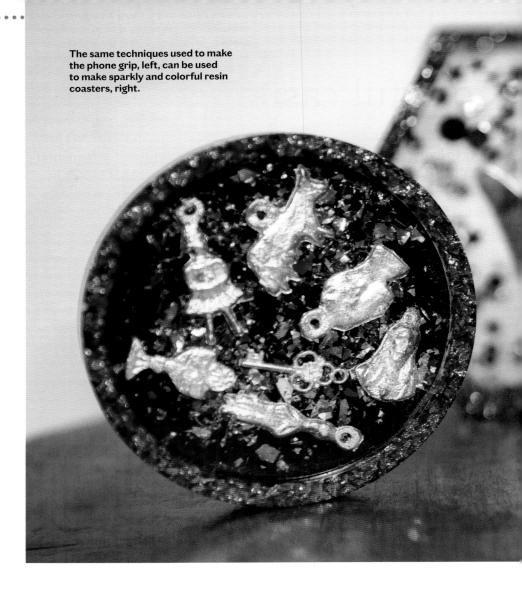

The same techniques used to make the phone grip, left, can be used to make sparkly and colorful resin coasters, right.

materials

- Two-part resin kit: resin, hardener, mixing cup, stirrer
- Resin colorant
- Glitter (optional)
- Heat gun or straw
- Protective gloves and mask
- *Milagros*
- Phone grip base (These can be found online.)
- Phone grip silicone mold of your choice (These can be found online.)
- Plastic tray or pieces of wood or cardboard lined with wax paper
- Sandpaper
- High-gloss water-based polyurethane spray varnish

Milagro resin phone grip

How does a phone grip relate to affirmations? If you're like me, you probably use your phone for everything: planning, communicating, creating, and even working on your business. This little phone grip is layered with happy goodness, glitter, and *milagros* (miracle charms) to make sure all activities happen with good vibes.

Makes one phone grip

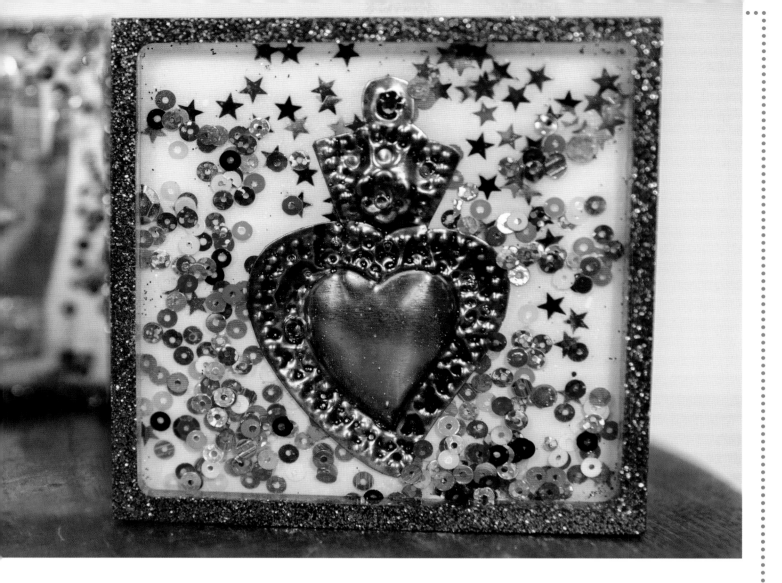

1. Set the silicone mold and the *milagros* on lined wax paper, a piece of wood, or cardboard.

2. Put on the gloves and mask.

3. Follow the manufacturer's directions to mix the resin. Slowly mix with a stirrer, such as a wooden stick, and try to avoid creating bubbles. Working on the lined wax paper tray, pour a small amount of resin into the silicone mold, creating a thin layer.

4. Use the heat gun to remove any bubbles in the resin or pop them by blowing through a straw onto the surface.

5. Wait 30 minutes and then set the *milagros* face down in the poured resin. Add a little bit more resin to cover the backs of the *milagros*.

6. Let the resin set for six hours and then repeat the process, this time adding three small drops of resin colorant or glitter to the resin during mixing.

7. Pour the resin into the mold until it is halfway filled and let cure for several hours.

8. Mix one more half-batch of clear resin and apply a dime-sized amount onto the mold and onto the phone grip base as the last layer—this is to bond the phone base to the resin base. Press the phone grip base in place. Let set.

9. Let the resin fully cure overnight and then remove it from the mold.

10. Use sand paper to smooth out the edges of the resin and spray with high-gloss water-based spray varnish.

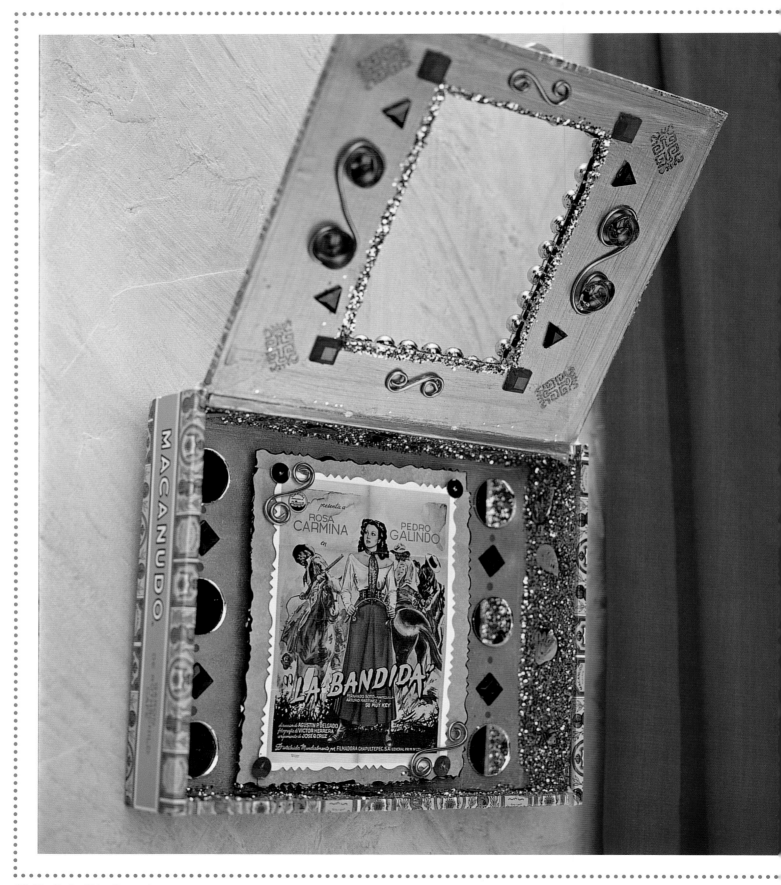

Cigar box travel shrine

The next best thing to visiting exotic locations is collecting postcards from them. A *nicho* is a great way to incorporate your travel memories or aspirations into an artful showpiece.

In this example, the lid of a shallow cigar box has been altered to serve as a door that opens to display a vintage Mexican postcard. Trimmed in glitter and gold, the box is further embellished with miniature mirrors, stamps, and craft gems.

Use a permanent marker to journal on the back of the box about why you made this shrine, where you want to travel, or what you loved about a recent trip. Think of it as a way to manifest your travel goals!

When it comes to the postcard, you can choose one with a favorite saying or a place you want to travel. Hang it where you can see it every day and bring it to life!

Makes one cigar box shrine

materials

- Cigar box with attached lid
- Postcard
- Acrylic craft paint in assorted colors
- Assorted paintbrushes
- Colored cardstock
- Wooden ball, 1/2" (3 cm) diameter
- Accent pieces: Mardi Gras beads, copper wire, miniature mirrors, foil decorations
- Loose glitter
- Glass pebbles
- Hot glue gun and hot glue sticks
- Scissors
- Craft knife
- Sawtooth picture hanger
- Ruler
- Pencil
- Sandpaper

1. With a ruler and pencil, lightly draw a 4" x 4 1/2" (10 cm x 11.5 cm) box in the center of the lid. Use a craft knife to remove the box to create a window in the lid. Sand the edges smooth.

2. Carefully remove the paper lining from the inside of the box and then paint a base coat in a desired color. Paint the inner sides of the box and then sprinkle on the loose glitter. Use hot glue to add accents. With hot glue, trim the front window with Mardi Gras beads and add the wooden ball as a knob.

3. Decorate the inner lid and top of the box.

4. Attach the postcard to colored cardstock and apply the glass pebbles to the back with hot glue. Center the cardstock inside the box and adhere. Add embellishments around the postcard's edges.

5. Attach a sawtooth picture hanger on the back.

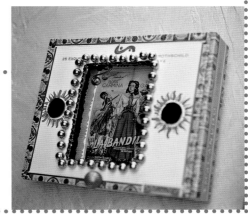

 Tip Let each step dry before moving on to the next one. Use decorative-edged scissors to trim the postcard. Add other personal mementos, such as coins, postage stamps, or letters.

Mis amigas greeting cards

materials

- Blank note cards with envelopes
- Mexican comic book or other ephemera of your choice
- Patterned stationery or metallic adhesive paper
- Clue stick
- Hot glue gun and hot glue stick
- Craft gems (optional)
- Stickers or fabric trim
- Scissors
- Ruler or tape measure

Nothing brings friends together more than scandalous plots! Forbidden love! Ruthless betrayal! Life-or-death secrets of the heart! We're not talking Hollywood movies, but rather . . . comic books? That's right. Except these cartoon page-turners are not for *los niños* (the kids), but more for the seasoned culture hound who prefers to walk on the wild side of souvenirs. The printed versions of Mexican *novellas* (soap operas) are just as hot and racy as the televised ones. Packed with juicy, nail-biting storylines and melodramatic characters, it's no wonder they are one of the most outlandish guilty pleasures of Mexican collectibles. Which is exactly why they work wonderfully as fun and funky note cards—and are sure to induce a giggle or two with your *amigas*.

If you want to skip the *novela* drama, you can always go with an empowering theme using your favorite scrapbook papers, stamps, and stickers (shown opposite bottom three).

Makes one note card and envelope

VARIATIONS Create a collage on the front of the card by cutting out a variety of pictures, such as Mexican horoscopes or make an accordion card and use a series of comic pictures.

1. Leaf through the comic book to find a vibrant picture for the front of your note card. If the book is black and white, use the color cover page. Trim the white border from around the picture.

2. Measure and cut a piece of stationery or metallic adhesive paper that is approximately 1/2" (1.5 cm) larger than the comic book picture. Use the glue stick to adhere it to the image as the background and then glue the picture in place at an angle or in the center of the card.

3. Add rows of stickers or hot glue fabric trim around the picture and embellish with craft gems, if desired. Maintain the theme by decorating the envelope as well. Cut a small scrap of paper and an image from the comic and adhere them to one corner of the front of the envelope or as a flap sealer on the back.

Tip Do not glue anything until you have first practiced different layouts. Work on a flat, clean surface to avoid wrinkling your card. Some comic books can be racy—you can use squeeze glitter or paint to cover cleavage if necessary.

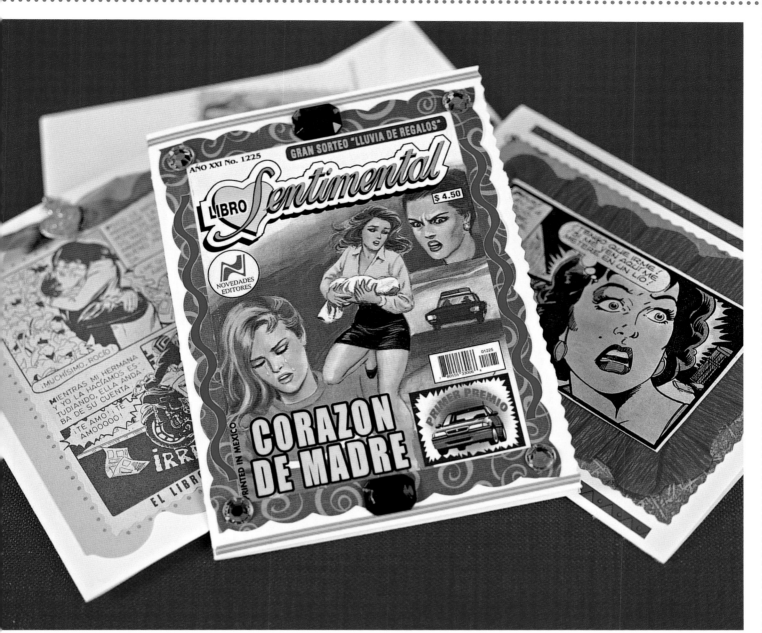

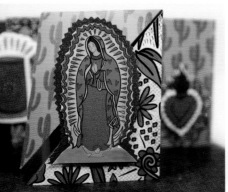

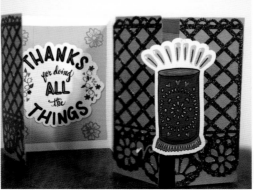

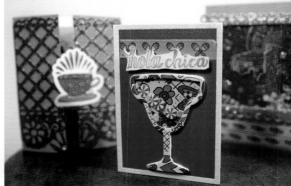

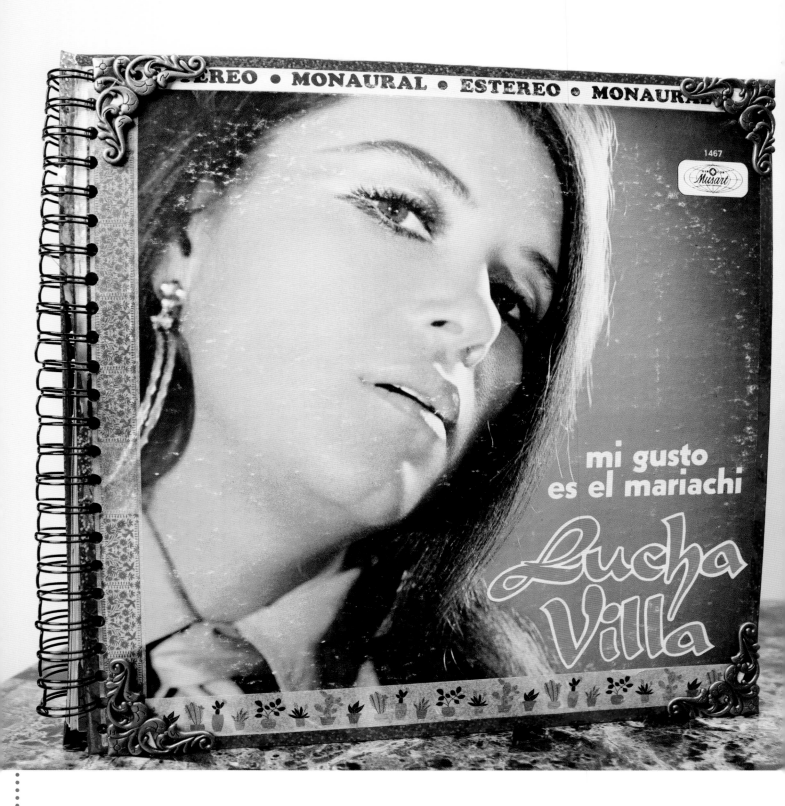

Diario de disco

You can never have too many journals, especially when they're as cool as this one! This hand-bound journal made from a vintage Spanish-language record album cover is perfect for writing your thoughts, drawing doodles, creating planner pages, adding ephemera or stickers, and more. Use it for a vision board, a photo album, or for brainstorming notes.

Creating this journal is also a wonderful way to use leftover scrapbook paper, envelopes, greeting cards, thin cardboard, and even fabric.

Makes one journal

1. Cut through the three album cover seams and separate into two pieces: the front and the back, about 12" x 12" (30.5 cm x 30.5 cm) each.

2. Give the album pieces a finished look by adhering pieces of washi tape around the edges. You can also stitch the edges with embroidery thread using a whip stich or cover the edges with pieces of metallic duct tape trimmed to fit.

3. Cut the pieces of paper so they're slightly smaller than the covers and arrange them in the order you want.

4. If using a home binding machine, hold the stack and tap them so they are even on the side that will be bound. I bound mine on the left side, but you can bind at the top or even the right side. Follow the manufacturer's instructions for binding the covers and papers.

materials

Record album cover (If you don't want to cut one up, make a color copy of the front and back, cut them to size, and laminate the pieces.)

Scissors or craft knife and cutting mat

Home spiral bookbinding tool, with a 1" (2.5 cm) binding wire of choice (Alternatively, you can take the cover and pages to an office supply store or local printer and have them spiral bound.)

25 to 30 pieces of assorted paper such as patterned, solids, vellum, journal, construction (I used 12" x 12" [30.5 cm x 30.5 cm] pieces to fit the album covers and added other odd sizes in between.)

Washi tape, six-strand embroidery thread and needle, or metallic duct tape

Assorted paper embellishments

Embellish the book with stickers, journal prompts, page tabs, and more.

Wood-burned retablo

VARIATION This concept can be used on larger wooden objects, such as jewelry boxes, wall hangings, or tabletops.

Retablos have been a prominent aspect of Latin culture long before the nineteenth century. Originating in Spain and derived from the Latin term *retro tabula* (behind the altar), they have been created by hand in many forms: from tin to wood, from simple to elaborate. *Retablos* are known for their beautiful images of patron saints or other types of pictures of devotion. They are used in a multitude of places for a variety of reasons. Many spiritual people and families use them as adornments in home altars, and others share them with loved ones at public memorials. It is believed that having a *retablo* or two within your environment will bring peace, happiness, good health, love, and prosperity.

Makes one *retablo*

1. If using unfinished wood pieces, draw an outline and use a jigsaw to cut out the pieces into the desired shape. Join the two pieces by installing a small hinge and hinge screws. Sand the edges smooth.

2. Using the wood-burning utensil, draw a design or image onto the front and back of the wood.

3. Use wood-stain markers or acrylic paint to color in the shapes or to add words or borders.

Tip Use transfer paper if you would like to use a picture instead of drawing freehand.

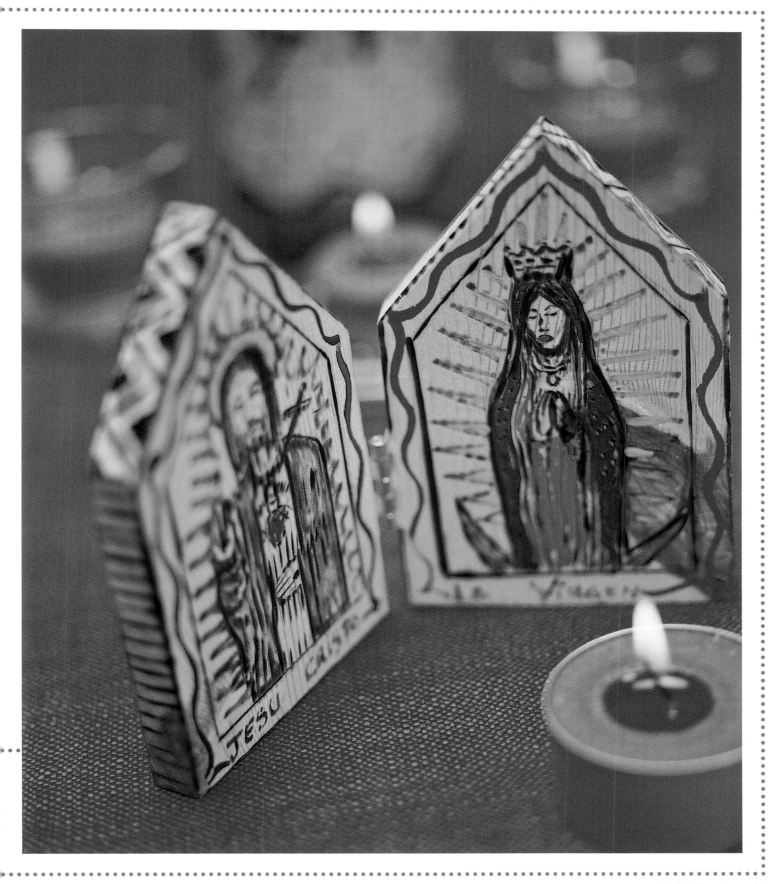

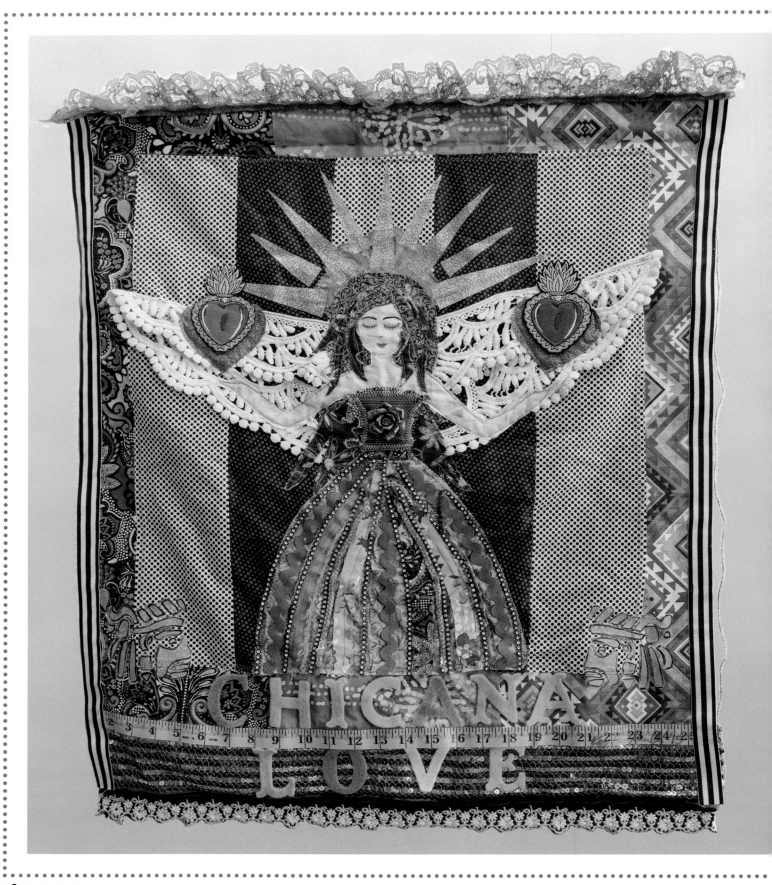

Chicana love wall tapestry

I made this tapestry as part of an art exhibit held in Arizona, where I live. She is strong and mighty and rules with positivity and purpose. I've always felt I have Aztec warrior angels protecting me, and I know you do too!

What does your warrior angel represent? Before beginning the project, do a bit of journaling and make a list of what you love about yourself, your life, and what you want your mission to be. We not only have our own set of warrior angels; we are warrior angels too. We have the power to uplift, inspire, and encourage!

Makes one tapestry

materials

- Angel template (see page 118) or use your own sketch of an angel
- Assorted fabric pieces, including at least one fat quarter (a ¼ yard cut that measures approximately 18" x 22" [46 cm x 56 cm]) for the tapestry base, and lace pieces
- Iron and ironing board
- Felt or felt letters
- Scissors
- Iron-on glitter sheets
- Pins
- Sewing machine or cotton sewing thread and needle
- Embellishments: milagros, rhinestones, or charms
- Washable permanent fabric glue (optional)
- Wooden dowel for hanging (The length should match the smaller measurement of the fat quarter fabric.)

1. Take inventory of the supplies you'd like to use to create and personalize your angel. Using a copy of the template on page 118 or your own sketch, note where you'll use specific fabrics and trims.

2. Press all the fabrics and choose a fat quarter to use as the base of the tapestry.

3. Choose fabrics to use for the angel's body and halo and lace pieces for the wings. I used collar lace, which was the perfect shape. Pin the template or sketch to the fabric and cut out the body and the halo.

4. Pin the body and halo pieces to the base fabric and arrange and pin the lace for the wings.

5. Sew the pieces in place by hand or machine and add any trims or embellishments. I added sacred heart *milagros* to the wings, rhinestones and a metal rose charm to the dress, and created hair out of strips of fabric. I embellished the halo with iron-on glitter cut into long triangles and created a face by using a small liner brush and fabric paint.

6. Fold over the top of the fabric and sew a hem, by hand or machine, wide enough to accommodate the dowel.

7. Choose a phrase to add to the bottom of the base fabric. Cut letters out of felt or use precut felt letters and either hand stitch in place using a whip stich, machine stitch, or use fabric glue.

8. Slide the dowel into the sleeve and hang. Add any additional accents to the piece.

Tip When pinning and sewing the angel to the base fabric, remember that you'll need a couple of inches (5 cm) of fabric at the top to accommodate the dowel sleeve.

5

Home Accessories

Sometimes, the best things come in small packages. Decorating with a Latin twist is no exception. When it comes to embellishing walls, furnishings, tabletops, or even whole rooms, those small packages translate into clever and cultural accent pieces.

The ideas in this chapter are eye candy exclamation points, meant to add splashes of cheer to ordinary areas that could benefit from a bit of perking up. Let your personality be your guide when determining how far you want to carry the Latin theme. *¿Un pequeño o mucho?* A little or a lot?

The projects in this chapter include funky picture frames, artistic trinket boxes, vibrant sofa pillows, and wild wall décor. How to incorporate one design into your dwelling—or maybe more—is up to you.

Don't panic if these ideas seem a bit overwhelming at first. The beauty is that each art piece can be altered and adapted by color, shape, or theme to fit your home's décor. If primary acrylic *colores* are brighter than you prefer, soften them with a dash of white.

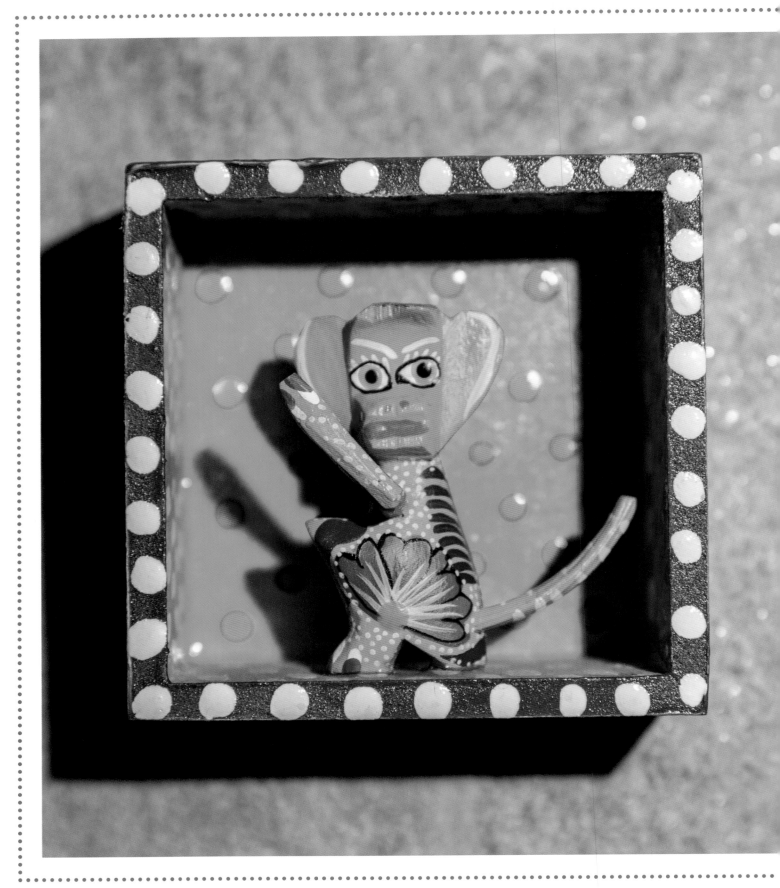

Alebrije shadow box

Alebrijes are wooden fantasy animals that originated in Oaxaca, Mexico, in 1936. Artist Pedro Linares was known for creating whimsical and elaborate piñatas, and one day while dealing with a very high fever, he dreamt about being in a forest meeting brightly colored animals with fangs, horns, spikes, wings, and tails. Once Linares recovered, he recreated his vision using papier-mâché. Ever since, *alebrijes* have been wildly popular and are often thought of as spirit animals.

As you shop for Mexican treasures, choose a small *alebrije* as your spirit guide. Create a glittery little home for it and set it out so you can see it every day!

Makes one shadow box

materials

- Small unfinished wooden shadowbox, 4" x 4" (10 cm x 10 cm)
- Small *alebrije*, about 3" to 3½" (7.5 cm to 9 cm) (You can find these at stores that sell authentic Mexican folk art or online.)
- Piece of scrap paper
- Loose glitter
- Acrylic craft paint in assorted colors
- Assorted paintbrushes
- Hot glue gun and hot glue sticks
- White craft glue

1. Paint the entire shadow box with a base coat of any color of acrylic paint. Allow it to dry.

2. Working over a piece of scrap paper, brush a coat of white glue on the inner sides of the box and pour the glitter on to cover. Tap away the excess glitter and put back in the jar.

3. Add painted details on the front and side of the box. I painted large dots on the inside of the box and around the front edge. Add hot glue to the bottom of the *alebrije* and set it inside the shadow box.

Sirena gorda pillow

While visiting San Miguel de Allende, a city in the central Mexico state of Guanajuato, my friends took me to a bar called La Sirena Gorda (fat mermaid) to celebrate my birthday. While there, I noticed a lot of Mexican tin art featured gorgeous chubby mermaids, happily posed like supermodels of the sea.

I wanted to make something themed around a *sirena gorda*, and this plushie pillow is perfect. This is a great easy sewing project for beginners. Display it on a couch or top off your bed in style.

Makes one mermaid pillow

materials

- Mermaid template (see page 118), or create your own mermaid drawing
- White duck cloth, two 20" (51 cm) square pieces
- Ruler or tape measure
- Iron and ironing board
- Scissors or rotary cutter and pinking shears
- Disappearing ink pen
- Brush-on fabric paint or acrylic craft paint in assorted colors (If using acrylic paint, it's best to mix it with an acrylic fabric medium so it remains flexible when dry.)
- Assorted paintbrushes
- Paper and pencil
- Sewing machine or cotton sewing thread and needle
- Polyester fiber fill pillow stuffing
- Clitter Mod Podge

1. Wash, dry, and press the duck cloth. Cut two pieces, each about 20" (51 cm) squares, and stack them.

2. Copy the template to scale and trace it onto one piece of fabric, using a disappearing ink pen. Alternatively, sketch your own *sirena gorda* on a piece of paper and then draw it on the fabric with the pen.

3. Place the fabric pieces wrong sides together and sew around the perimeter of the image using a running stitch, leaving a 5" (13 cm) open space at the bottom to add stuffing later. If machine stitching, backstitch at the beginning and end of the opening. Turn the pillow right-side out through the opening and press.

4. Sketch the mermaid's head, tail, guitar, and hands with the disappearing ink marker.

5. Use a small liner brush to paint the face, body, arms, and hands with skin-tone paint. Allow to dry.

6. Paint the body, tail, guitar, and hair. Allow to dry.

7. Sketch the mermaid's facial features with a pencil and go over the lines with paint using a small liner brush. Add white accents for highlights on the eyes. Allow to dry. Brush on Clitter Mod Podge to seal the paint. Allow to dry.

8. Stuff the pillow with the filling and hand-stitch the opening, using a slip stitch.

9. Use pinking shears to cut away the excess fabric from your sewed outline.

10. Trim with stitched embroidery thread using either a running stitch or a banket stitch or use an acrylic paint marker to add a line of color around the perimeter.

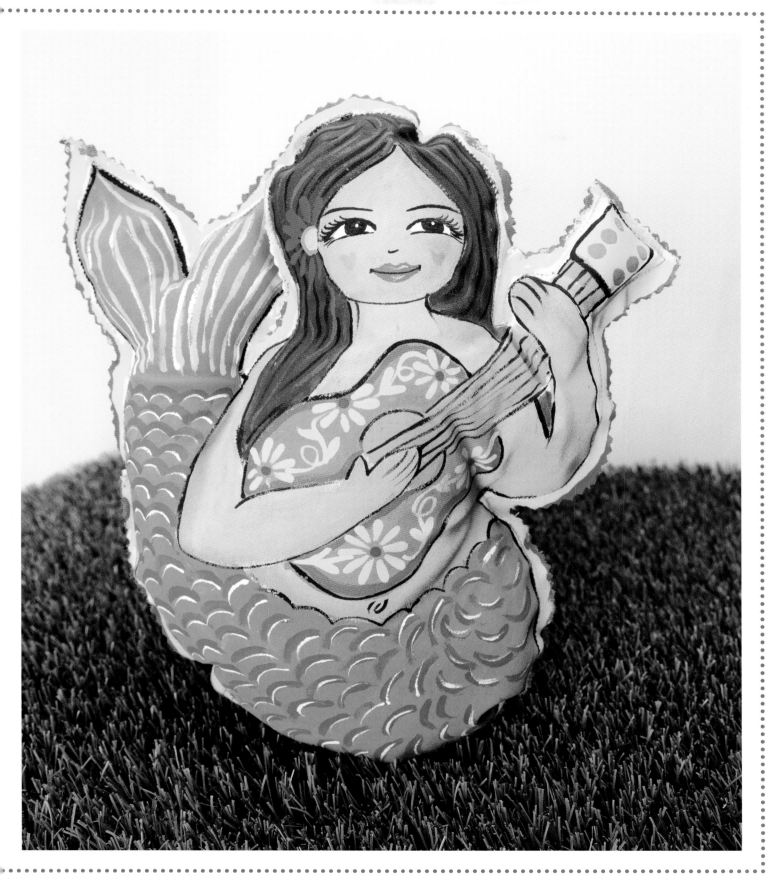

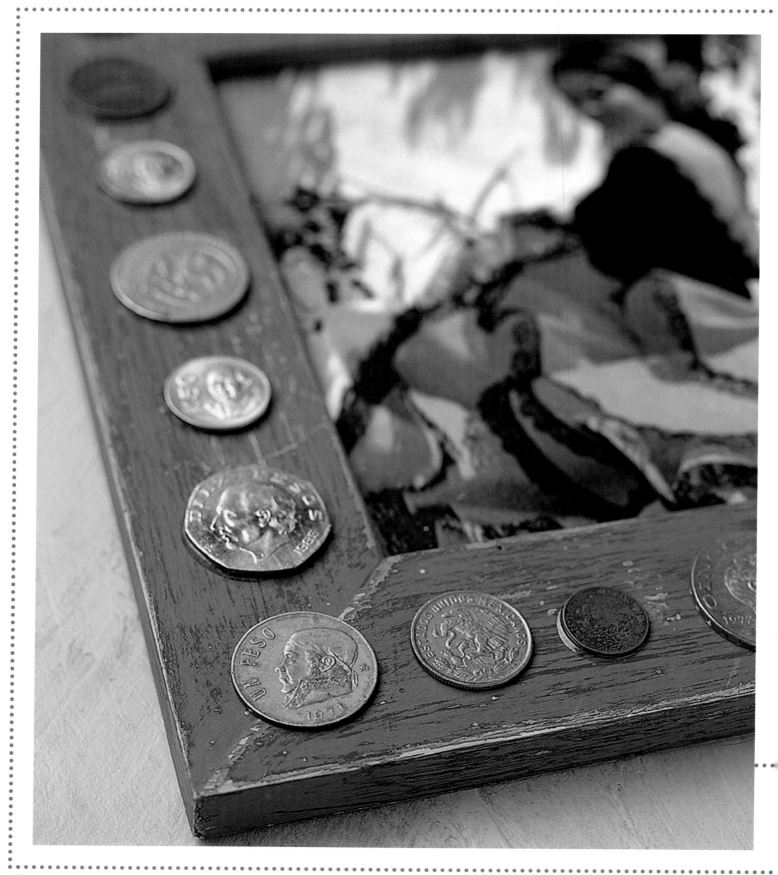

Peso picture frame

Avoiding Mexican *mercados* is as unheard of as ordering a basket of tortilla chips without the salsa. From Mexicali to Mazatlán, each city offers a treasure trove of treats to buy and bring home. Hats, toys, food, magazines, furniture, and more are all available for a price, thanks to the gracious vendors that are known for wheeling and dealing. It doesn't matter if the purchase is as *grande* as a luxurious leather sofa or as *poco* as a pack of peppermint *chicle*, loose change is always a factor. No matter what, there is always some left over. Make the most of it by using a handful of those spare Mexican pesos to add some cultural value to a picture frame. Unless you need them for your next shopping trip.

Makes one frame

materials

- Piece of glass and backing board, 8" x 10" (20.5 cm x 25.5 cm)
- Wood frame, 10" x 12" (25.5 cm x 30.5 cm) with a 2" (5 cm)-wide border
- Acrylic craft paint in yellow, lime green, blue, and purple
- Paintbrush
- 28 to 30 assorted peso coins
- Industrial-strength craft glue
- Sandpaper
- Sawtooth picture hanger or easel stand

VARIATIONS Use more coins to create a random collage-like design or add grout to make a mosaic.

1. Lightly sand the frame and then paint a yellow base coat. Let the paint dry and then repeat the process with the remaining colors. Let each color dry between coats.

2. Sand the entire surface so that the layered colors show through. You should be able to see all the colors on the wood.

3. Working on a flat surface, set the frame down and arrange the coins around the border to create a balanced look. Working one coin at a time, add a small dollop of industrial-strength glue and press the coin firmly to the frame's surface. Let it dry for several hours.

4. Insert the glass and backing board. Either attach the sawtooth picture hanger or use an easel stand.

Tip Keep checking the coins as you glue them to make sure they don't slide out of place. Pesos can also be purchased at various financial institutions.

materials

Shadow box frame,
9" x 9" (23 cm x 23 cm)

Favorite piece of fabric or
patterned paper, 9" x 9"
(23 cm x 23 cm)

Double-sided extra-
strength dry adhesive
sheets

Inspirational words (use
the template on page 118)
cut with an electronic
die cutter (Alternatively,
letters can be cut by
hand, painted on with
enamel paint, or alphabet
letter stickers can be
used to spell out words.)

Electronic die cutter

Vinyl sheets

Transfer tape

Burnishing tool

Scissors or craft knife and
cutting mat (optional)

Enamel craft paint
(optional)

Paintbrush (optional)

Alphabet letter stickers
(optional)

Inhala, exhala sign

Sometimes you just need a reminder to breathe. Inhale. Exhale.
Inhala. Exhala.

Taking a pause to do breathing exercises is a great way to release anxiety
and stress. You can inhale and think about the blessings in your life, the
little things that went right; then, exhale to let go of the tension, self-doubt,
and worrying.

Create this artful reminder and place it in your office or wherever you
feel you need it most. Always make time to take a break for self-care and let
yourself breathe.

Makes one sign

1. Place the shadow box glass-side
 down and remove the backing board.
 Cover the board with fabric or
 patterned paper. Choose something
 that makes you happy when you
 see it. You can even use a picture
 of yourself at one of your happiest
 moments. Adhere the fabric, paper,
 or photo to the backing board with
 dry adhesive sheets.

2. Cut the words *inhala* and *exhala*
 from the desired color vinyl sheets
 using an electronic cutting machine;
 alternatively, you can cut the letters
 by hand, use enamel paint, or apply
 alphabet letter stickers.

3. If using vinyl sheets, peel the vinyl
 from the negative space to reveal the
 words and apply transfer tape to the
 back of the words. Burnish the letters
 so they adhere to the transfer tape
 and then apply them to the shadow
 box glass.

4. Carefully burnish the letters again
 so they adhere to the glass and then
 carefully peel away the transfer tape.

5. If using an alternate method, paint
 the words on the front of the glass
 with enamel paint or apply letter
 stickers to the front of the glass.

6. Reattach the backing board to the
 shadow box frame.

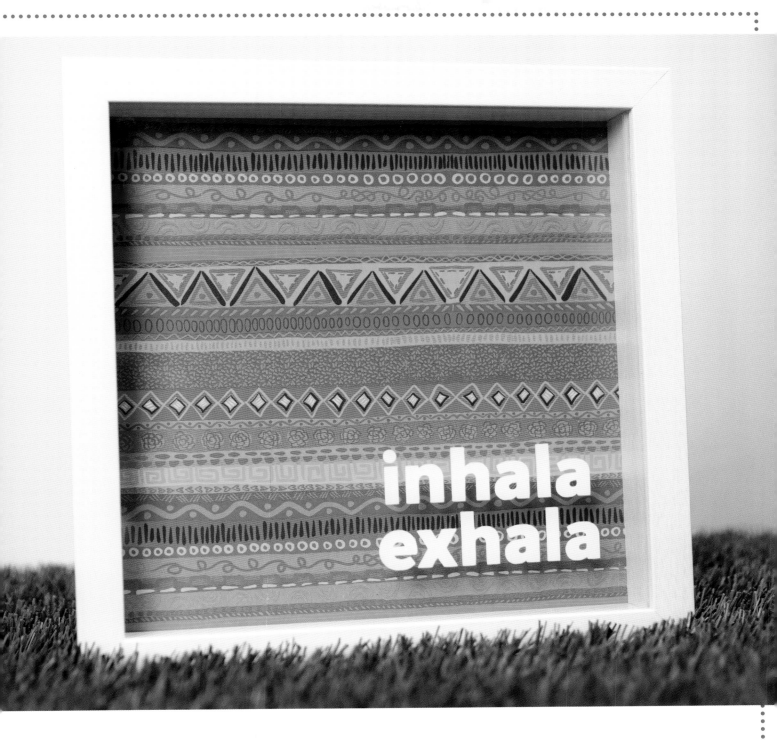

materials

Flat, chunky frame

Dress, blouse, or fabric
featuring Mexican
or other Latin-style
embroidery or
threadwork

Hot glue gun and hot glue
sticks

White craft glue
(optional)

Fabric tape (optional)

Pinking shears

Ruler or tape measure

Paper and pencil

Mexican-embroidered picture frame

Pictures need a "wow" factor to showcase them, and this frame delivers.
We all love the beautiful threadwork of Mexican and other types of
Latin embroidered textiles that go beyond blouses. Check
thrift stores for embroidered tops that can be cut and altered in a
multitude of ways. You can make purses, tote bags, jewelry, and in
this case, a vibrant frame.

Makes one frame

1. Lay the embroidered garment on a
 flat surface and measure the height
 and width of the embroidered areas.
 Note the measurements on a piece
 of paper.

2. Measure the four panels that make
 up the frame to determine how
 much fabric is needed. Make sure to
 add 1" (2.5 cm) around each side of

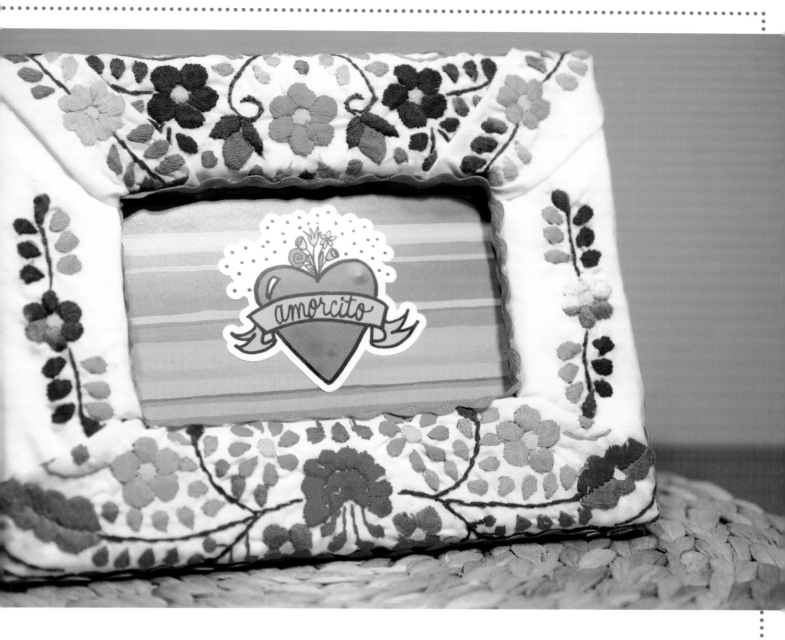

each fabric piece to wrap around the panels.

3. Cut four fabric pieces for each frame panel according to the measurements using pinking shears.

4. Remove the backing board and glass from the frame.

5. Position the fabric pieces on top of each corresponding frame panel.

Hide the raw edges by folding the fabric to create a hem for the embroidered motifs. Use hot glue or fabric tape to secure.

6. Set the fabric pieces in place on the frame and take the time to fold the edges and layer them so the corners look mitered.

7. Use hot glue or white glue and secure the fabric pieces tightly in place around the inside ridge of the frame and around the outside, leaving room to insert the glass and backing board.

8. Keep adjusting the fabric until it is taut around the frame.

9. Replace the glass, add your photo, and replace the backing board.

Tamale oja wreath

Tamales are one of the main staples of Mexican food—especially around the holiday season. From soaking the *ojas* (corn husks) and shredding the meat to peeling the chilies and mixing the *masa* (corn-based dough), they are the most fun to make. But not everyone can be a champion tamale maker. That's the idea that triggered the next best thing—an art piece celebrating tamales! This savvy Southwest-style wreath uses dried *ojas* as its foundation and dried chilies as the final touch. For crafty types, it's the perfect alternative to making tamales—no soaking, shredding, mixing, or peeling required!

Makes one wreath

materials

1 straw wreath, 10" (25.5 cm)

1 bag of cornhusks

2 to 3 dried red chilies

12" (30.5 cm) of Guatemalan ribbon, 1" (2.5 cm) wide

String or wire

1 box of straight pins

Hot glue gun and hot glue sticks

VARIATIONS If desired, replace the ribbon with raffia and dried chilies with imitation ones. Split the husks down the center and use a 6" (15 cm) wreath for a smaller version.

1. Break apart the cornhusks into single sheets. Take one husk at a time and fold it gently in half. Lay it in the center of the wreath and insert a straight pin through it to hold it in place.

2. Apply the next husk in the same fashion, except attach it 1/2" (1.3 cm) lower than the previous one. Repeat the process until you have a row that lies evenly in the inner circle.

3. Repeat the process in the opposite direction for the front of the wreath. Continue to the outside of the wreath, again going in the opposite direction.

4. Wrap two or three dried chilies together at the stem and tie the group to a string. Tie a knot at the top of the string and pin it to the top of the front of the wreath. Tie a bow with the ribbon and hot glue it on top of the string to hide it.

Tip Each husk will take two pins to fully secure it in place. Do not use husks that come from a bag that has been open for more than a week because they will be too dry to use and will split when the pin is inserted.

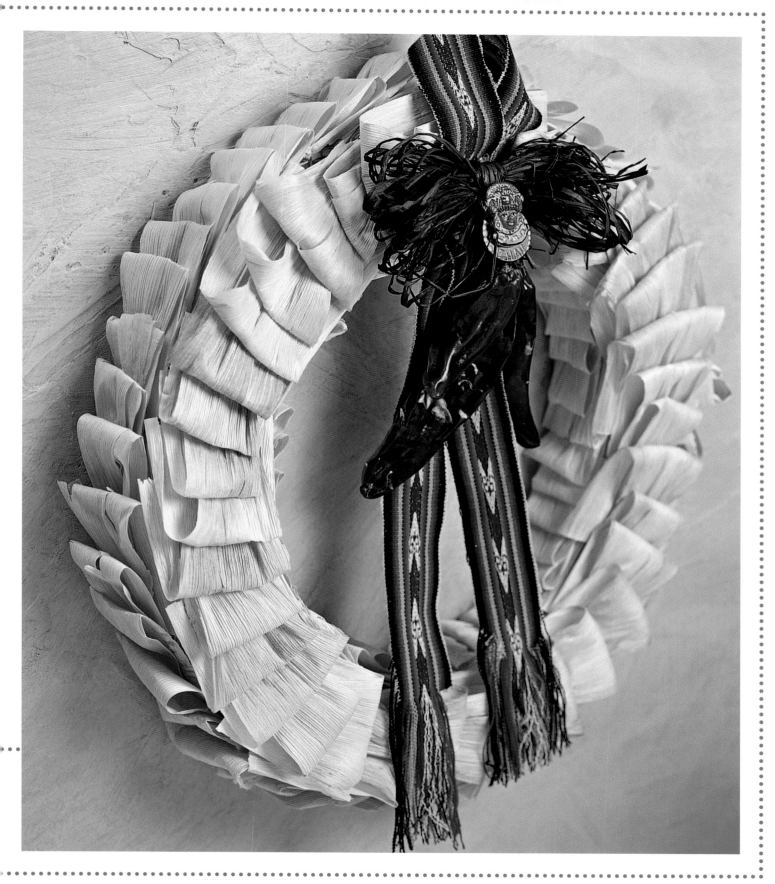

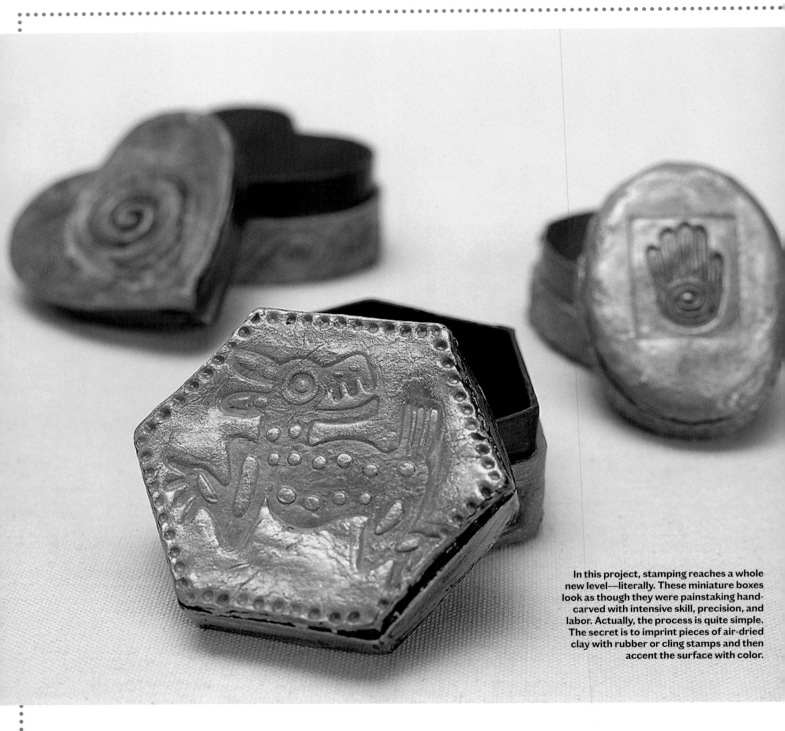

In this project, stamping reaches a whole new level—literally. These miniature boxes look as though they were painstaking hand-carved with intensive skill, precision, and labor. Actually, the process is quite simple. The secret is to imprint pieces of air-dried clay with rubber or cling stamps and then accent the surface with color.

Tip Smooth out cracks in the clay or blend areas together by dipping your finger in water and gently rubbing the area.

Stamped folk art boxes and ring dish

Makes one box

1. Work on a clean, flat surface. Pinch off a chunk of clay and use the roller to flatten it to a 1/4" (6 mm) thick. Cover the box with the clay, one side at a time, and trim it to size using the craft knife. Do not cover the area where the lid overlaps the box. Return the pieces to a flat surface.

2. Stamp your phrase or design on each piece. Use a foam craft brush to paint a layer of white glue onto the surface of the box and adhere each stamped piece one by one. Let the clay and glue dry for several hours.

3. Paint the uncovered areas of the box (such as inside the box, lip, and lid) in a desired color and let dry.

4. Use your finger to gently rub one color of paint across the stamped clay. Repeat the process with an additional color and once more with the gold-toned paint.

5. Varnish the box with a foam craft brush and water-based varnish. Let dry.

materials

- 1 small chipwood or papier-mâché box
- Air-dry terra-cotta clay
- Small rubber or cling stamps
- Acrylic craft paint in two or three desired colors
- Assorted paintbrushes
- Gold-toned acrylic craft paint
- Water-based polyurethane brush-on varnish, your choice of matte or gloss
- White craft glue
- Small foam craft brushes
- Clay roller
- Craft knife

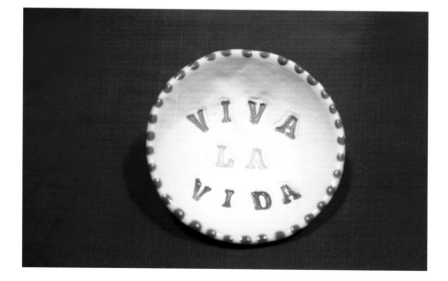

VARIATION To make a ring dish, roll out a slab of the clay, cut in a circle, stamp your phrase or designs, and then place in a shallow bowl to shape and air dry. Paint as above.

T-shirt toss pillow

Mention the idea of "Latin-izing" a home and T-shirts aren't exactly the first thought to come to mind. But in this case, they are the magic ingredient— that is, if you have a fabulous one that you don't mind cutting up. Here's a cheerful way to preserve the color and crispness of the shirt (or shirts) by transforming it into a gorgeous throw pillow for a sofa or bed. The shirts used in these examples have all been lovingly worn throughout the years. Instead of tossing them out, recycle them!

I'm a collector of Latinx tees and used four of them sewn together on one side as a panel, and then on the front I used colorful fabric and stitched the T-shirt phrase in the center and trimmed it with rickrack.

Makes one pillow

materials

- Polyester fiber fill pillow stuffing
- 20" (51 cm) square of printed fabric, washed and ironed (one for the front and four for the back)
- Screen-printed cotton T-shirts, washed
- Trim, such as ribbon, rickrack, or sequins
- Sewing machine or cotton sewing thread and needle
- Scissors
- Ruler or tape measure
- Iron and ironing board
- Straight pins

VARIATIONS Printed bandanas can be substituted for T-shirts. Decorate your pillow as mellow or extreme as you like. Use different types of fabrics, such as chenille or velvet, for different looks.

1. Set the 20" (51 cm) square fabric piece on a flat surface. For the front center motif 10" x 10" (25.5 cm x 25.5 cm) panel of the pillow, pin the design from the T-shirt to the center. Machine stitch or hand stitch in place using a whip stitch. Add trim around the design if desired.

2. For the other side of the pillow, cut four more T-shirt designs that each measure about 10" (25.5 cm) square.

3. For the back of the pillow that has the four t-shirt pieces, sew two squares using a running stitch, right sides together, and then sew the other two the same way.

4. Take the two pieces you just sewed and pin the center sides together (right sides facing in) and sew them together. This will be one sids of the pillow.

5. Press the seams open.

6. Take the two panels (front and back) you just made and create the pillow sleeve: pin the front and back panel together and sew three sides together.

7. Turn the pillow right-side-out and add the pillow stuffing.

8. Fold in the fabric edges at the bottom and sew using a slip stitch or ladder stitch to close up the pillow.

9. Add any kind of trim you want to dress it up even more.

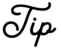

Tip Allow extra margins for fabrics that unravel easily or that will need an edge-finishing overcast stitch.

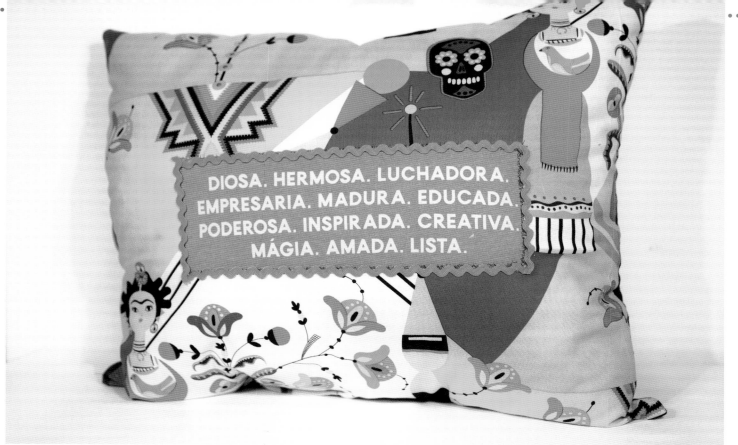

DIOSA. HERMOSA. LUCHADORA. EMPRESARIA. MADURA. EDUCADA. PODEROSA. INSPIRADA. CREATIVA. MÁGIA. AMADA. LISTA.

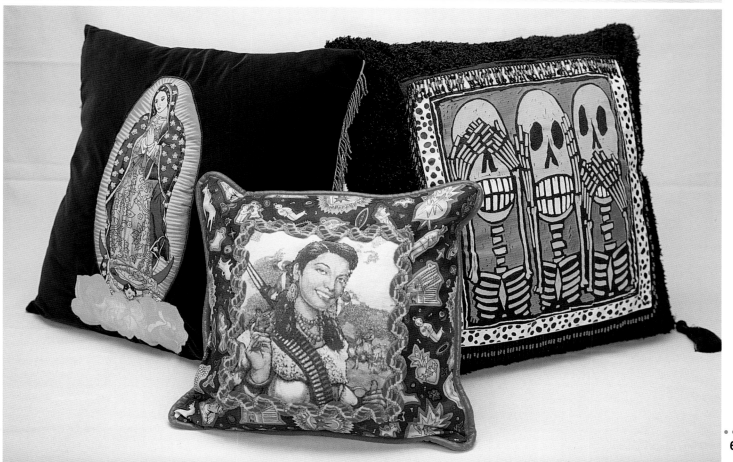

Tip Make sure the box is completely dry after each step before moving onto the next. Before gluing the plaque in place, find the center of the box and lightly mark it so you know where to permanently adhere the plaque.

Flashy flamenco box

Elegant, flamboyant, mesmerizing, and breathtaking—these are qualities that make flamenco style the respected and beloved art it is today. With castanets in hand, gorgeous Spanish women decked out in tiered, ruffled lace skirts, chunky black heels, bolero brims, and oversized hoop earrings sure know how to keep the Mediterranean Latin spirit alive. But flamenco music and dance are much more than meets the eye. Its exotic and emotional energy soothes the soul by way of eloquent guitar melodies, romantic vocals, and heart-pounding lyrics, accompanied by the sharp feet stamping, hand clapping, skirt flipping, and tricky twirls. If visiting Spain (or a local flamenco show) isn't on your current agenda, why not assemble a keepsake box such as this? This wooden jewelry case is overflowing with lace, mirrors, and flowers in an attempt to capture a bit of that Spanish vigor and vitality. To that, we say *Olé*!

Makes one jewelry box

materials

- Wooden jewelry box, 12" x 4" (30.5 cm x 10 cm)
- 1½ yards (1.5 m) of black lace
- 22" (56 cm) black ball trim
- 2 flamenco coasters or pictures
- 4" x 6" (10 cm x 15 cm) wooden plaque
- 4 miniature round mirrors
- 4 wooden balls, 1" (2.5 cm) in diameter
- Acrylic craft paint in black, red, white, purple, blue, yellow, and green
- Assorted paintbrushes
- Water-based polyurethane brush-on varnish, your choice of matte or gloss
- Industrial-strength craft glue
- Hot glue gun and hot glue sticks

1. Apply a base coat of acrylic paint on the inside of the box (black), the top (red), and the sides (green).

2. Paint the wooden plaque black and glue one of the coasters or pictures to the center of it using industrial-strength glue. Paint green vines and leaves with yellow, purple, and blue flowers. Apply water-based vanish, let it dry, and then affix the black ball trim around the rim using hot glue.

3. Hot glue the now-decorated wooden plaque to the center of the jewelry box. Glue a miniature mirror in each corner using industrial-strength glue and add white dots of acrylic paint around the edges of the mirrors. Create petals around each mirror for accents. Cover the remaining surrounding areas with brush strokes of greenery and flowers. Add rows of dots around the side of the lid and apply a layer of water-based varnish.

4. Open the box and glue the other coaster or picture inside the lid with industrial-strength glue and add painted accents around it. Paint the wooden balls and glue them with industrial-strength glue to the bottom of the box. Apply a layer of water-based varnish to cover the entire box.

5. Close the box and use hot glue to trim the bottom sides of the box in the black lace.

VARIATIONS For a simpler look, apply the coaster or picture directly to the box without using the plaque. Trim the plaque in the same type of lace as you use on the bottom of the box.

Bossa nova barstool

That sexy bossa nova beat can be oh-so-soothing to the soul and addictive to the feet and hips. But after suavely dancing the night away to exotic Brazilian samba rhythms, there comes a point when even the best of partiers needs a little rest. Let this swanky barstool come to the rescue. It's more than just comfy and colorful—it's downright cool.

Makes one barstool

materials

- 24" (61 cm) wooden barstool
- 1/2 yard (46 cm) of Mexican oilcloth
- Round seat cushion, 12" (30.5 cm) in diameter, 2" (5 cm) thick
- 1 yard (91.5 cm) of black ball trim
- Acrylic craft paint in assorted colors
- Assorted paintbrushes
- Water-based polyurethane spray varnish, your choice of matte or gloss
- Spray adhesive
- Hammer and gold-colored tacks
- Staple gun and staples
- Hot glue gun and hot glue sticks
- Scissors
- Sandpaper

1. Lightly sand the barstool. Paint a base coat in the desired colors and add accents in contrasting colors. Let dry. In a well-ventilated area, spray on three coats of water-based varnish, letting each one dry before the next one is applied.

2. Spray a generous layer of adhesive to the seat's surface and to one side of the cushion. Carefully set the cushion on the seat, making sure it is even. Trim any excess with scissors.

3. Lay out the oilcloth face down on a table. Turn the barstool upside down and place it on the cloth. Pull one side up underneath the seat area and staple. Continue the process until the cloth is tightly bound underneath the seat.

4. Flip the barstool over and attach the black ball trim around the rim of the seat with hot glue. Hammer in the tacks to make it more secure.

VARIATIONS Replace the oilcloth with another type of strong fabric, such as a Mexican blanket or other vinyl covering. Use leftover oilcloth to make drink coasters that match the barstools. Simply glue the fabric to 4" x 4" (10 cm x 10 cm) ceramic tiles or wooden pieces and add felt tabs to the bottom to protect tabletops. Instead of covering a barstool, use this technique on chairs or ottomans.

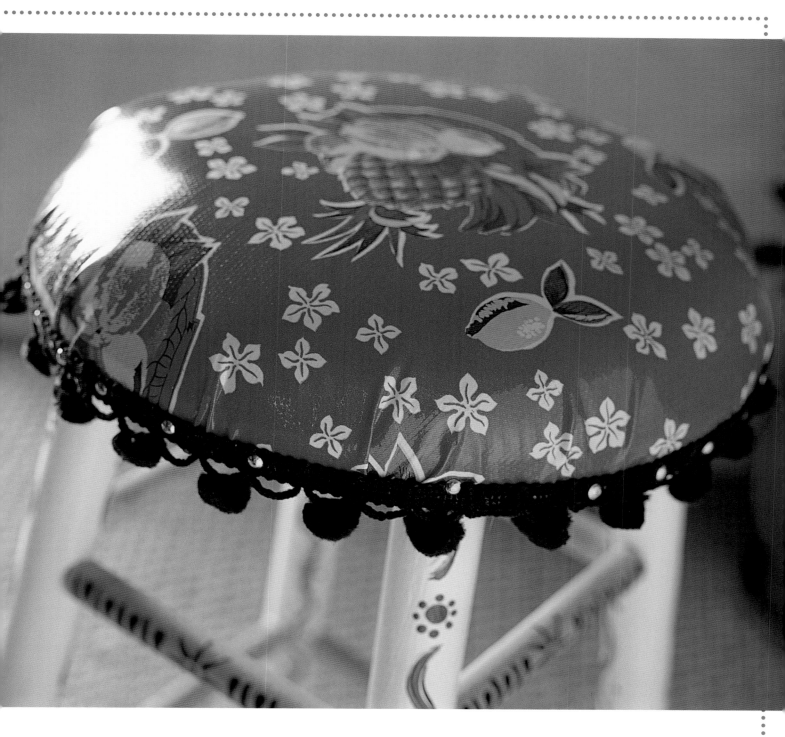

Tip Use hot glue to keep the cloth tightly in place as you staple it.

6

Jewelry and Accessories

In this bustling world, just about everyone can appreciate the value of personal space; it's *muy sagrado*—very sacred. The only objects we allow within our inner circle are those personal items that are near and dear to our hearts.

The fascination with these treasures is truly in the eye of the beholder. Sure, it sounds a bit syrupy, but don't break out the melodramatic *balada* just yet. Personal accessories aren't always sentimental. Think of that crazy *tia* who can't get enough of her hot-pink flamingo brooch or the co-worker who has her desk covered with kooky newspaper or magazine clippings. These are just two examples of how much fun it is when our personal space overflows into our personal style.

Accessories can include one-of-a-kind jewelry pieces worn faithfully each day, vintage family photos on a fireplace mantle, and even yummy scented candles. Together or separately, they are some of life's little ingredients that reflect our moods and define our personalities. This is where handcrafted mementos fit in. Designed as a form of expression, they have the good intention to inspire or humor.

The following projects are all about constructing a dashing collection of Latino-centric keepsakes. Plenty of diverse accessories can be made for yourself, with extras to be shared with cherished *compañeros*.

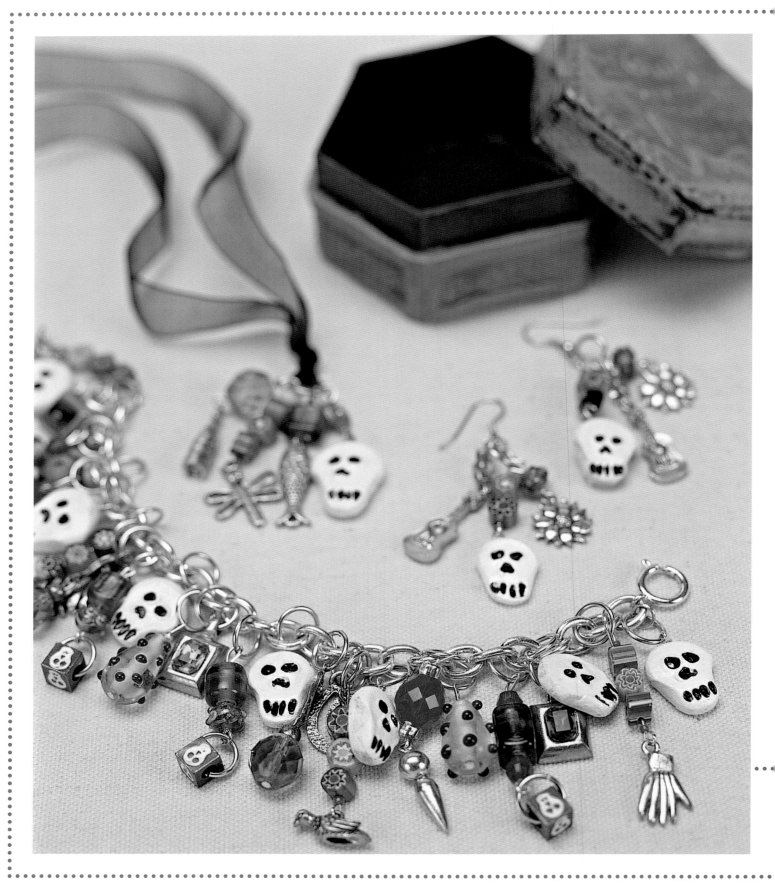

Crazy calaca jewelry set

Día de los Muertos is all about frivolity and flair. On this beloved holiday, nothing can be too outlandish or too wild. This jewelry sets the tone for the festivities to come. It is tightly packed with a rousing array of multicolored and ethnic beads, charms, and handmade miniature *calacas* (skeletons) that glow with mischievous glee. This project is a bit on the focused side, but offers a chance to joyfully reflect on the lives of those who have touched our hearts. And just like our memories, this set is welcome year-round.

Makes one jewelry set

1. Pull off a pea-sized piece of clay and press it between your fingers to make a circle. To make the skulls, pinch the bottom of the circle to form a square jaw. With a ballpoint pen, make two holes for the eyes, an upside-down V for the nose, and lines for the teeth. Use a head pin to poke a hole at the top of the skull. Repeat the process to make 15 skulls and bake them according to the manufacturer's directions. Let cool and then dip a head pin in the black paint and fill in the holes you made with the ballpoint pen. Let them dry and brush on a layer of water-based varnish.

2. On a head pin, thread one bead sandwiched between two seed beads. Snip the excess from the pin. Set aside and repeat the process until you have 20 beaded head pins. Make another set using the eye pins.

3. To incorporate the clay skulls, snip 15 of the eye pins down to 1" (2.5 cm) long. Add a dab of extra-strength glue at the end of the pins and insert them through the hole at the top of the skull.

An eyehole will protrude from the top of each skull. Attach these skulls as danglers for your jewelry pieces.

4. With the needle-nose pliers, attach the head pins to the eye pins and then to a jump ring at the top. Lay the bracelet out flat and arrange the beaded pieces below it to create an appealing and balanced pattern. Once you find a pattern you like, use the pliers to attach the pieces.

5. To make the earrings, make two sets of three beaded head and eye pins. Attach them to the fishhook earrings.

6. To make the necklace, repeat the process using six sets. After attaching the jump rings with the beaded head and eye pins, thread the ribbon though. Tie a knot at both ends to secure.

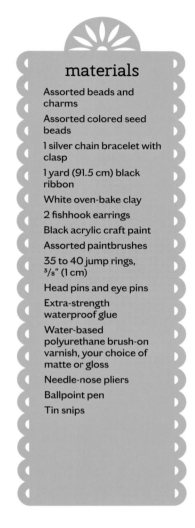

materials

- Assorted beads and charms
- Assorted colored seed beads
- 1 silver chain bracelet with clasp
- 1 yard (91.5 cm) black ribbon
- White oven-bake clay
- 2 fishhook earrings
- Black acrylic craft paint
- Assorted paintbrushes
- 35 to 40 jump rings, ³/₈" (1 cm)
- Head pins and eye pins
- Extra-strength waterproof glue
- Water-based polyurethane brush-on varnish, your choice of matte or gloss
- Needle-nose pliers
- Ballpoint pen
- Tin snips

VARIATIONS To make a choker necklace, shorten the length of the ribbon and use fewer beads. For a less busy bracelet, use fewer pieces and no eye pins. Replace the bracelet chain with thick elastic cording.

Tip For the earrings, only use lightweight beads. Make sure the jump rings are tightly closed; otherwise, the head and eye pins will fall through.

Sparkly oilcloth earrings

When you're a crafty chica, oilcloth isn't just for table coverings or purses—it works beautifully as jewelry too! Oilcloth is cotton fabric that's been coated with vinyl, making it super shiny and durable. If you live a life of adventure, these babies will hold up nicely!

I made these earrings jumbo-sized because I have big hair and love big earrings, but you can adapt them to your liking. Big earrings = *mucho* super powers!

Makes one pair of earrings

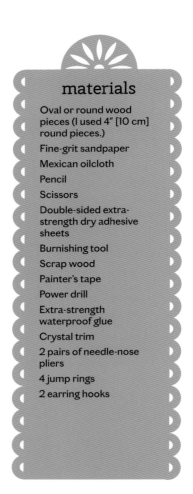

materials

Oval or round wood pieces (I used 4" [10 cm] round pieces.)

Fine-grit sandpaper

Mexican oilcloth

Pencil

Scissors

Double-sided extra-strength dry adhesive sheets

Burnishing tool

Scrap wood

Painter's tape

Power drill

Extra-strength waterproof glue

Crystal trim

2 pairs of needle-nose pliers

4 jump rings

2 earring hooks

1. Lightly sand the wood pieces, removing any rough or uneven spots.

2. Decide which portions of the oilcloth to use for the earrings; the fabric will cover the wooden pieces. I chose areas with a variety of colors and patterns, which make the earrings more interesting.

3. Using a wooden piece as a template, place it on the oilcloth and trace around it with a pencil. Cut out four shapes using scissors.

4. Cut out four more shapes from the dry adhesive sheets using the same method.

5. Remove the backing from one side of the adhesive shape and adhere it to one of the wood pieces. Remove the other piece of adhesive backing and place one of the oilcloth shapes on top. Burnish the oilcloth to make sure it's adhered. Repeat on the other side and for the other wood piece.

6. Place one earring piece on a piece of scrap wood and anchor it firmly with painter's tape. Drill a small hole in the top of the piece, about 1/8" (3 mm) from the edge, with a power drill. Repeat for the other earring piece.

7. Carefully apply a bead of extra-strength glue around the edge of one earring piece and adhere the crystal trim. Allow it to dry. Repeat for the other earring piece.

8. Grip each end of a jump ring with a pair of needle-nose pliers. Twist the jump ring open and insert it into the hole of one earring piece. Add a second jump ring and close the first one by twisting it back in place and making sure the ends are flush. Adding two jump rings will make the earrings face front. To make the earring face outward, use one jump ring. Add the earring hooks and close the jump ring.

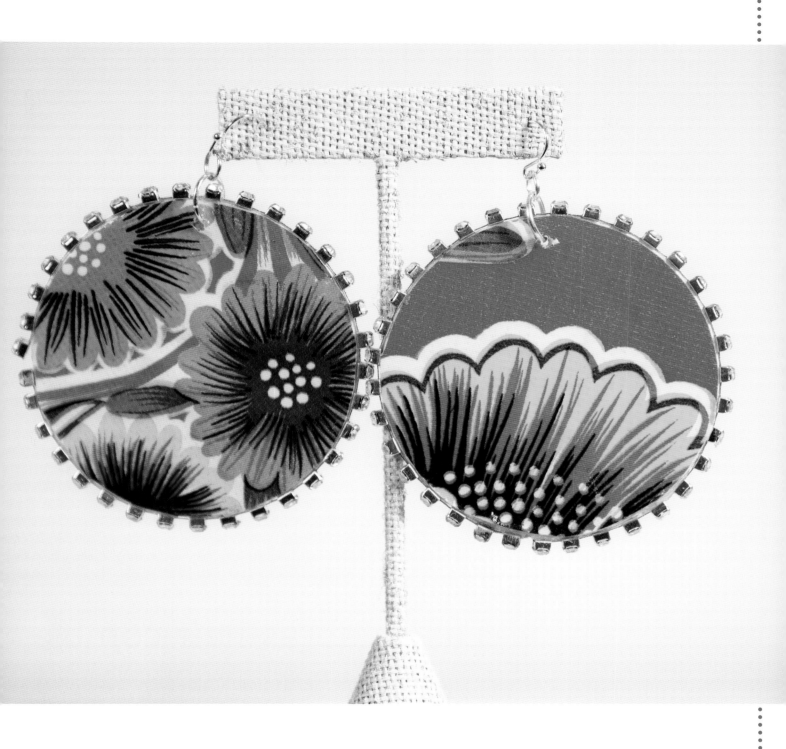

materials

Mini hair combs
(1¹/₂" [4 cm] long)

Hot glue gun and glitter
hot glue sticks

Small letter beads

Tweezers

Silicone mat

Scissors

Las palabras hair combs

Are you in the mood to make a statement with your hair, but don't want to look too wild? You'll love making and wearing these dainty *palabras* hair combs. At first, they may seem too small to create anything exciting with, but trust me—a bit of hot glue and letter beads go a long way!

Number of hair combs will vary

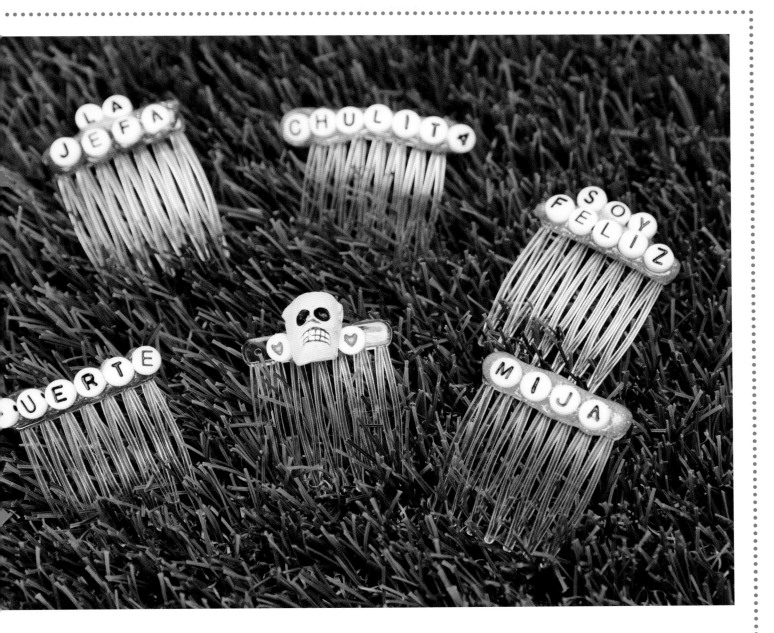

1. Select the letter beads for the words you want to create. The hair comb is only 1½" (4 cm) long, so make sure the words will fit. Arrange the letters and set them aside, but keep them close enough so you can quickly grab them when needed.

2. Prepare a hot glue gun with a glitter glue stick.

3. Working on a silicone mat, create a thick line of hot glue over the top area of the hair comb.

4. Use the tweezers to quickly pick up the letter beads, one bead at a time, and press them in place into the glue.

5. Don't worry if the hot glue extends a bit beyond the end of the hair comb; it will dry thick and sturdy.

6. Let the hair comb cool and then use scissors to snip off any hot glue strands.

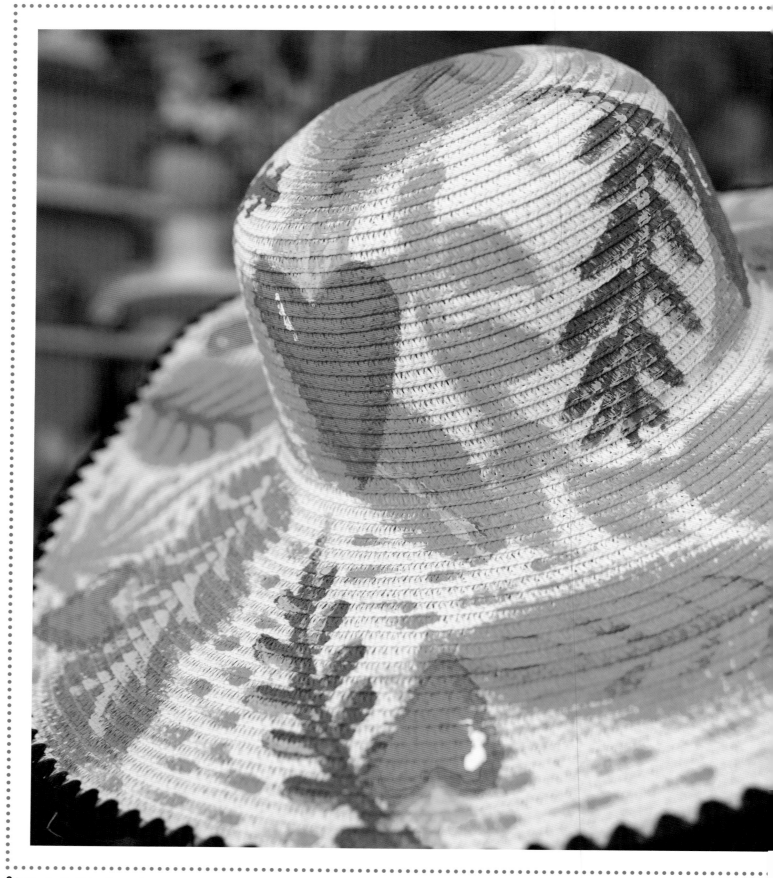

Las plantitas painted hat

Any time is a good time to wear a floppy hat. Whether at the beach or in the garden, your head will be graced with the magic of *las flores*!

This project has a multitude of options. Choose a favorite pattern or motif and feature it around the brim and crown. I love using a specific color palette for a botanical theme. You may choose to use every color imaginable for a floral design. These hats come in an array of styles and colors and are easily found in stores and online.

Makes one hat

materials

- Floppy, wide-brim sun hat
- Sketchbook or paper and pencil
- Acrylic craft paint in assorted colors, plus white and black (optional)
- Assorted paintbrushes
- Water-based polyurethane brush-on varnish, your choice of matte or gloss
- Microfine glitter (optional)

1. If the hat has a decorative band, remove it. You can replace it later.

2. Use a sketchbook to plan your design. Consider what motifs you want to include and sketch them to make sure they'll fit and to get the hang of creating the shapes. Draw designs in different sizes to create interest. When making your pattern, keep in mind that the designs will need three to four layers of paint: a white base coat, a background, a highlight, and an optional outline.

3. Determine the placement of the largest motif, positioning it in three or four spots on the hat. Create an organic but balanced design that will be pleasing to the eye. I created a pattern of sacred hearts and bold leaves.

4. Paint each motif white. Since these types of hats have texture, this will make the final color even and bright, since the base coat creates a smoother surface. Allow the paint to dry after this and all subsequent layers.

5. Paint the other motifs. If you're not sure about placement yet, do one at a time.

6. Paint the motifs in your chosen colors, and paint from dark to light. For example, if you're painting a red rose, apply your darkest red first and then progress to the lightest shade, ending with the highlights.

7. Paint white highlights in areas where you want to add shine or detail. I added a bit of white to my hearts. As an option, outline the motifs in back, using a small liner brush.

8. Assess the design and decide where to add glitter accents. To do this, mix a small amount of microfine glitter with water-based varnish and add it to the design with a small brush. Allow it to dry.

9. Apply water-based varnish to all the painted areas with a soft brush and allow the hat to dry.

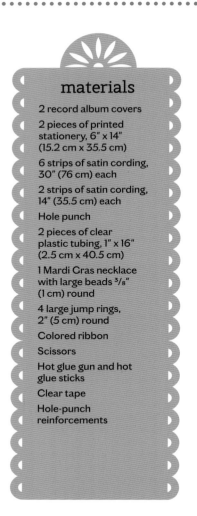

materials

- 2 record album covers
- 2 pieces of printed stationery, 6" x 14" (15.2 cm x 35.5 cm)
- 6 strips of satin cording, 30" (76 cm) each
- 2 strips of satin cording, 14" (35.5 cm) each
- Hole punch
- 2 pieces of clear plastic tubing, 1" x 16" (2.5 cm x 40.5 cm)
- 1 Mardi Gras necklace with large beads ³/₈" (1 cm) round
- 4 large jump rings, 2" (5 cm) round
- Colored ribbon
- Scissors
- Hot glue gun and hot glue sticks
- Clear tape
- Hole-punch reinforcements

VARIATIONS If desired, cut a Guatemalan belt to use as handles instead of tubing or embellish the outside further with rhinestones and glitter. Create a matching wallet or sunglasses case.

Mariachi tote bag

Vinyl has been making a comeback in the music industry. But why should the record players have all the fun? Often, the cover art is just as entertaining as its grooved contents. Case in point: vintage Mariachi records. The bold images are bursting with character and campy flair. It would be a shame to stash them in a dusty record collection where they can't be adored and appreciated. If you can lace a shoe and don't mind making a quick stop at the copy center, this quirky, easy-to-assemble tote bag is calling your name. Whether it's used at the sandy beach to hold a towel and sunscreen or to hold clothes for a casual weekend getaway, carrying this bag around will definitely allow you to arrive in signature style.

Makes one tote bag

1. At your local copy center, have all your paper laminated. If your albums are thick, have them laminated twice. Trim the laminated edges, leaving a ¹/₂" (1.5 cm) border all the way around.

2. Starting with a side panel (the printed stationery) and front panel (an album cover), line up the edges evenly. Make sure the image is facing outward. Apply a small piece of tape to hold them in place. Punch a line of holes approximately ¹/₂" (1.5 cm) apart along the edges of the stationery and album cover.

3. Lace the two pieces together using the satin cording. Continue the process until all four sides are connected. Repeat to attach the bottom.

4. Punch a hole through the plastic tubing ¹/₂" (1.5 cm) on each end and then two holes on the top of the album covers. Add the hole-punch reinforcements. Thread the Mardi Gras necklace into the tubing and then connect the handles to the bag with the jump rings.

5. Use hot glue to trim the edges with colored ribbon. Make inward creases in the side panels by pressing the two album cover sides together.

Tip Use the hot glue to seal any open edges of the laminate. For heavy-duty usage, connect the panels with grommets and leather.

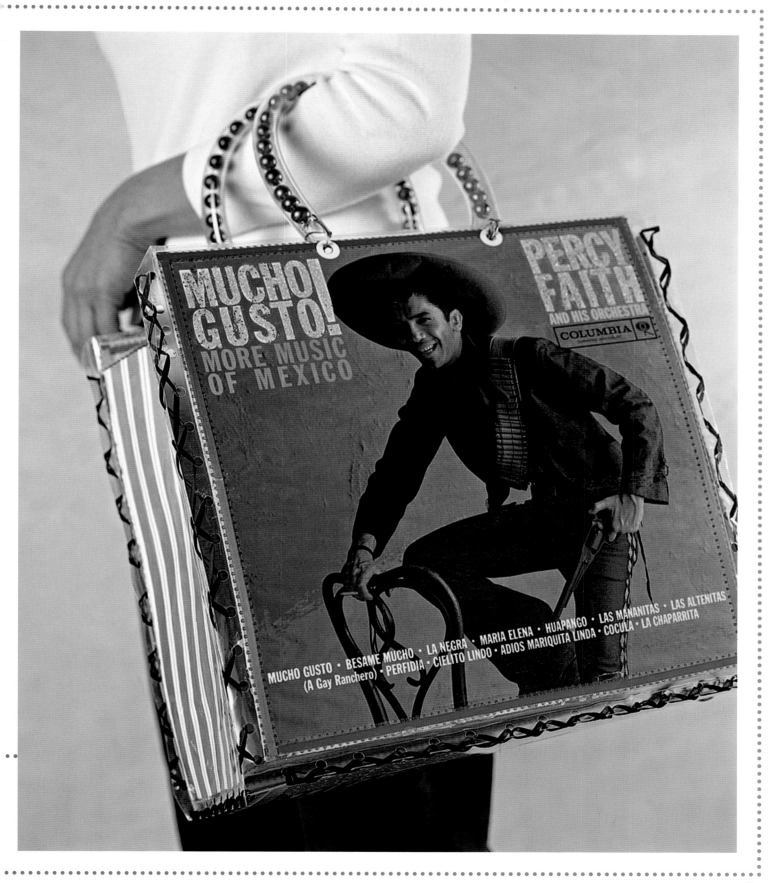

7

Garden Decorations

A happy Mexican garden means a happy Mexican meal—if you're the type who grows your own vegetables, that is. Whether you're planting jalapeño seeds for an upcoming salsa marathon or tending to a batch of elegant nopales, don't neglect livening up your leafy landscapes. Plants are living entities that thrive in positive, fruitful surroundings, much like humans. That's reason enough to create original art pieces for the garden!

Red, green, and yellow jalapeños nestled inside a bowl look as zesty and spicy as they taste. Aside from inducing a craving for a cool glass of sangria, the combo also conjures up images of gorgeous multi-colored gardens that are bursting with brightly curved bell peppers, long ears of multicolored corn, and blooming flores. Keep this imagery in mind when accessorizing your flower beds and greenery with Latin flair.

Before getting started, take time to explore your garden or patio. Think about carrying the mood you want to develop into your work—and workspace. If you live in a climate that offers wonderful weather, set up an art table outdoors so you can make cultural creations within the environment in which you will display them.

Once you've outfitted the garden with all sorts of handmade *tesoros* (treasures), share the idea seeds. The projects in this chapter make for expressive, heartfelt gifts for your favorite friends and loved ones. Think of it as snipping a branch from your imagination tree and passing it on for others to nurture in their own special way.

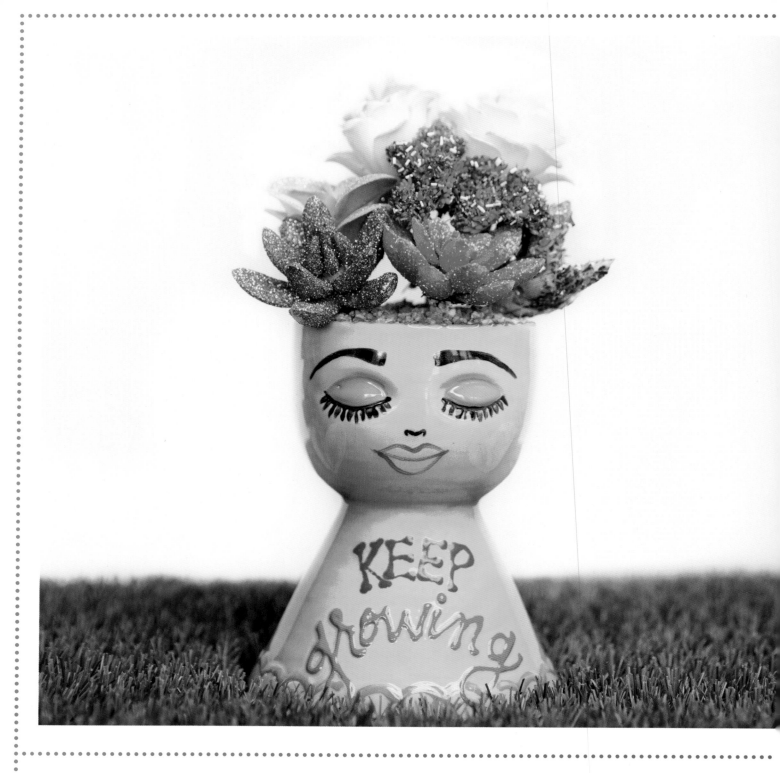

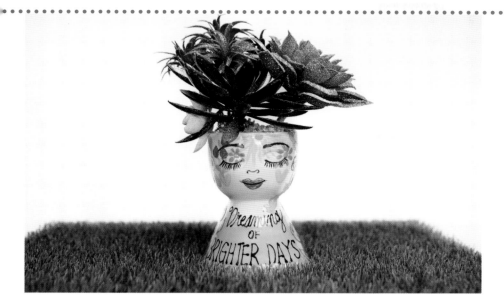

materials

- Assorted plastic cacti (available in craft stores or online)
- Assorted loose glitter in various textures and sizes in shades of green
- Satin finish spray paint in your desired colors
- White craft glue
- Foam craft brushes
- Water-based polyurethane spray varnish, your choice of matte or gloss
- Planters or flowerpots to fit the cactus
- Floral foam blocks
- Acrylic craft paint in assorted colors
- Assorted paintbrushes
- Hot glue gun and hot glue sticks
- Straw, rocks, or faux moss
- Large piece of scrap paper to catch glitter overspill

Glittered cactus planter

If you read my novel, *Waking Up in the Land of Glitter*, then you know all about making a glittered cactus garden centerpiece. The characters in the book went through a lot of heartache, joy, self-awareness—and most of all craftiness—to make 200 centerpieces for the National Craft Olympics.

The good news is you can just have fun and make a centerpiece to add some sparkle to your living space.

Makes one planter

1. Working in a well-ventilated area, spray paint the faux succulents in your desired colors. If they are already your preferred colors, you can leave them as is. Allow them to dry thoroughly.

2. Brush the succulents with white glue and while the glue is still wet, pour on the glitter to cover. Use a different type of glitter for each cactus to give it dimension and add interest. Allow the glue to dry.

3. Once dry, in a well-ventilated area, spray the succulents with water-based spray varnish. You can use a foam block to hold the cactus pieces upright while spraying. Allow the varnish to dry.

4. Paint and decorate the flowerpots or planters. First, paint on a base coat and let dry. Then, add details and embellishments. I painted faces, words, and flowers on mine.

5. Insert a block of floral foam cut to size into the painted pots and insert the cactus pieces into the foam. For a front-facing cactus garden, place the tallest and largest pieces in the back, medium-size ones in the middle, and smaller ones in the front. Hot glue the cactus pieces in place.

6. Cover the floral foam with straw, small rocks, or faux moss.

Tin plant pokes

materials

Mexican tin ornament

Skewers

Acrylic craft paint in assorted colors

Paintbrush

Industrial-strength craft glue

Scissors

The sad part about holiday decorations is the need to pack them up and send them to the storage room for the next 11 months. Just say no when it comes to doing this to Mexican tin ornaments. There are so many year-round ways to use the many happy shapes and themes that they come in: armadillos, cats, cacti, bulls, angels, hearts—the list goes on. For this project, they stay among the greenery, but not in their original use. After being glued to a colorfully painted skewer, they become vibrant plant pokes. It's just a little reminder to keep the uplifting holiday cheer year-round.

Makes one plant poke

1. Snip off the notch for hanging at the top of the ornament.

2. Place a 1" (2.5 cm) dollop of industrial-strength glue on the flat side of the skewer and press it to the back of the ornament. Set aside face-side down until the glue is completely dry.

3. Paint the skewers to match the ornaments.

4. Insert the poke into the soil next to your plants.

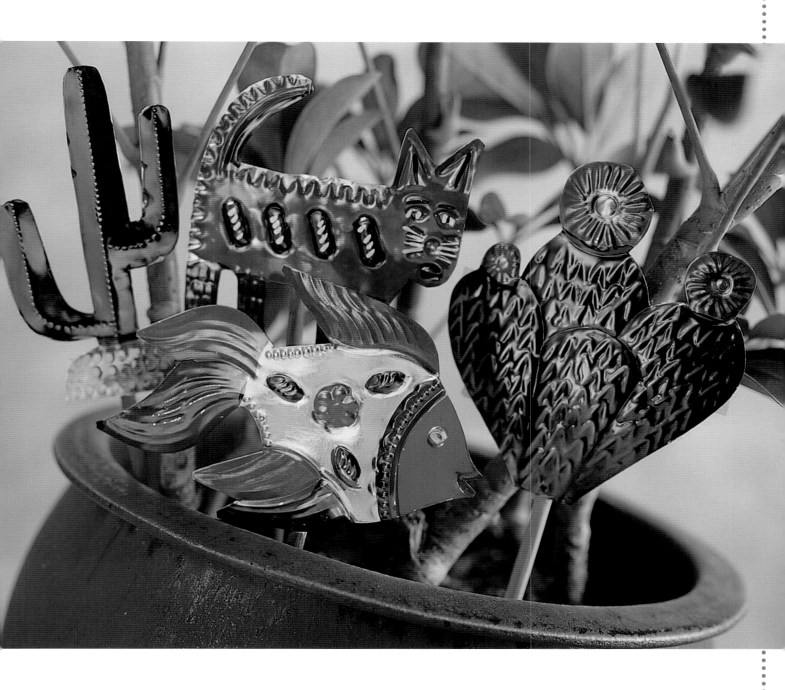

VARIATIONS Make an assortment of plant pokes by using different ornaments. Add strands of ribbon for more color.

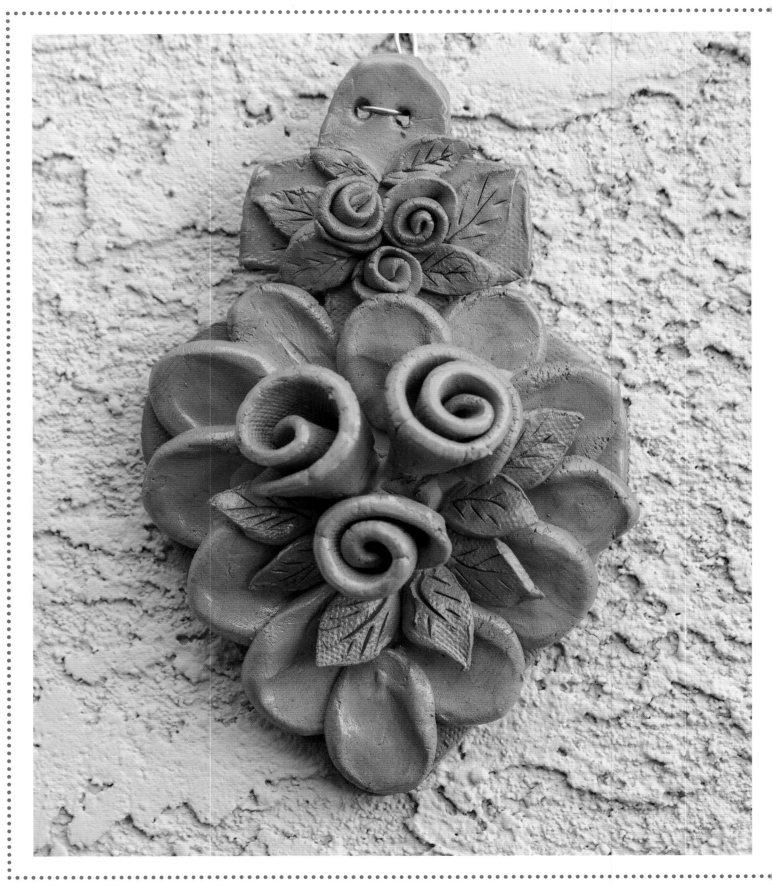

Terra-cotta sacred heart

Terra-cotta clay is a versatile and beautiful art material. You can find a variety of terra-cotta pottery, dinnerware, planters, and more, all with a distinctive artist's touch. My favorite are the *corazones*—the decorative hearts.

Some terra-cotta clays must be fired in a kiln to harden, but I've found a fabulous alternative: air-dry clay! This clay comes in the traditional reddish-brown color and in white, which can be painted. I prefer the former.

These hearts will add love anywhere you hang them. Let the natural color shine through or add bright paint to make them pop. The hearts can also be customized with a saying or name.

This project is perfect for a group craft night, and the finished item makes a great gift.

Makes one piece of terra-cotta art

materials

- Plastic tablecloth
- Flat board, poster board, or blank canvas board
- Air-dry terra-cotta clay
- Craft foam
- Small rolling pin dedicated for clay
- Template (see page 118)
- Craft knife
- Small cup of water
- Bamboo or wooden skewer
- Metal cooling rack
- Acrylic craft paint in assorted colors (optional)
- Assorted paintbrushes
- High-gloss water-based polyurethane brush-on varnish
- Wire or jute rope

1. Clean your worktable so it's free of dust and debris and cover it with a plastic tablecloth—terra-cotta clay is messy to work with. Work with the clay on a flat board dedicated for clay or on a poster board or blank canvas.

2. Cut a piece of clay about the size of a softball and roll it in your hands until it becomes a smooth ball.

3. Place they clay on the craft foam and flatten it with a rolling pin until it's about 6" x 4" (15 cm x 10 cm) and about 1" (2.5 cm) thick. Keep in mind that the clay shrinks slightly as it dries, as the moisture evaporates.

4. Place a copy of the template on top of the clay and cut out the shape using a craft knife. Alternatively, cut the shape freehand.

5. Roll out another ball of clay the same as the first and cut more piece for other elements, such as leaves, small rolled flowers, s and a banner.

6. Add some clay to a small cup of water to create a mixture called *slip*; the solution should be the consistency of heavy cream. This acts as the glue for the clay pieces.

7. To attach two pieces of clay, score both pieces with a craft knife where they'll adhere. Brush some slip on both sides and press the pieces in place.

8. Continue adding pieces to embellish the heart, making sure to connect each joint by scoring the clay and adding slip.

9. Create two holes at the top of the piece for hanging using a wooden or bamboo skewer.

10. Allow the clay to dry for two hours and then peel off the craft foam. Place the clay piece on a cooling rack or other metal grid and allow it to dry completely for another 48 hours.

11. Leave the piece as is or add color with acrylic paint. Seal with high-gloss water-based varnish, which lends a deep, rich color. Thread wire or jute rope through the holes and hang.

materials

- 1 can of Mexican chilies, 8 ounces (225 g)
- 3 pieces of chain, 8" (20.5 cm) each
- Jump rings, $^3/_8$" (1 cm)
- Dangling charm
- Class votive holder
- Votive or tea light candle
- Power drill
- Can opener
- Sandpaper

VARIATIONS Use another type of food can to add contrast. Instead of a basic chain, use a silver Cuatemalan wedding necklace or coiled colored wire. Remove the label from a basic can and paint your own designs on it.

Spicy candle lanterns

Much like a shot of tequila, every digested chile has a tale to tell. Whether inflicting a bout of "extreme watery eyes" syndrome or causing a grown man to scream out in pain, canned chilies sure can spice up mealtime. Don't toss the can just yet. Save it. Respect it. Know it. Keep a flame burning in it so it may forever serve as a reminder of what could be if its contents fall onto the wrong taste buds. You have been warned.

Makes one lantern

1. Remove the top of the can. Empty, thoroughly clean, and dry the can. Sand the edges at the ridge to remove any sharp points.

2. Drill three holes at the top of the can (just below the ridge) in a triangle fashion, in order to attach the chains. Drill two holes close together at the bottom of the can. Attach a jump ring to each hole at the top and one through the two holes at the bottom.

3. Hook one chain strip to each jump ring. Gather them at the top and connect with two jump rings. Add a dangling charm to the bottom jump ring.

4. Insert the glass votive holder and candle into the can. Hang and light.

 Tip Do not hang the lantern in direct sunlight, unless you want it to rust.

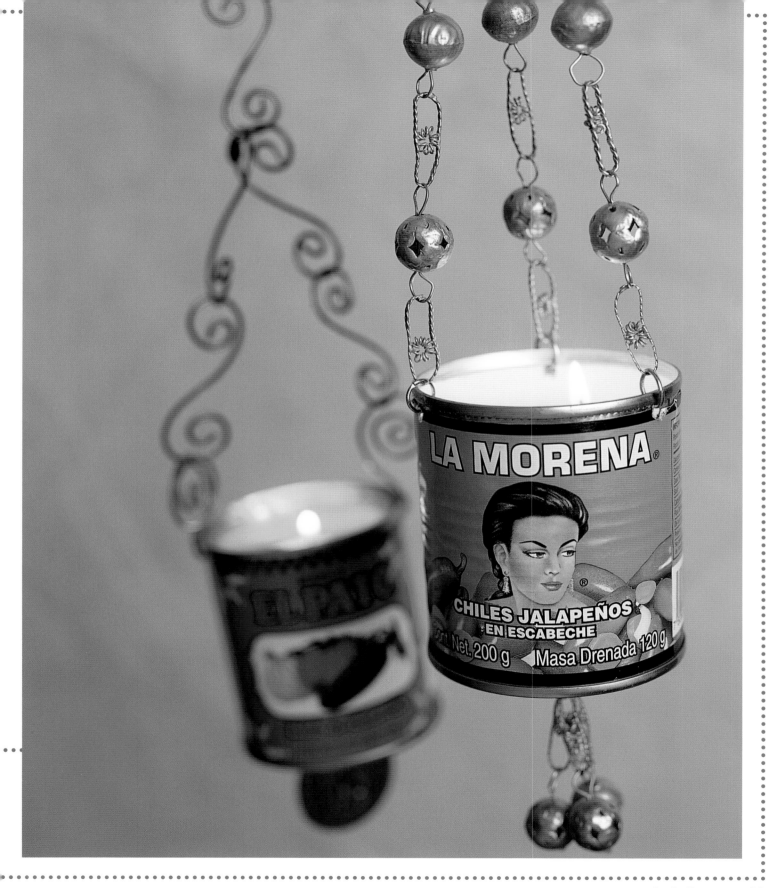

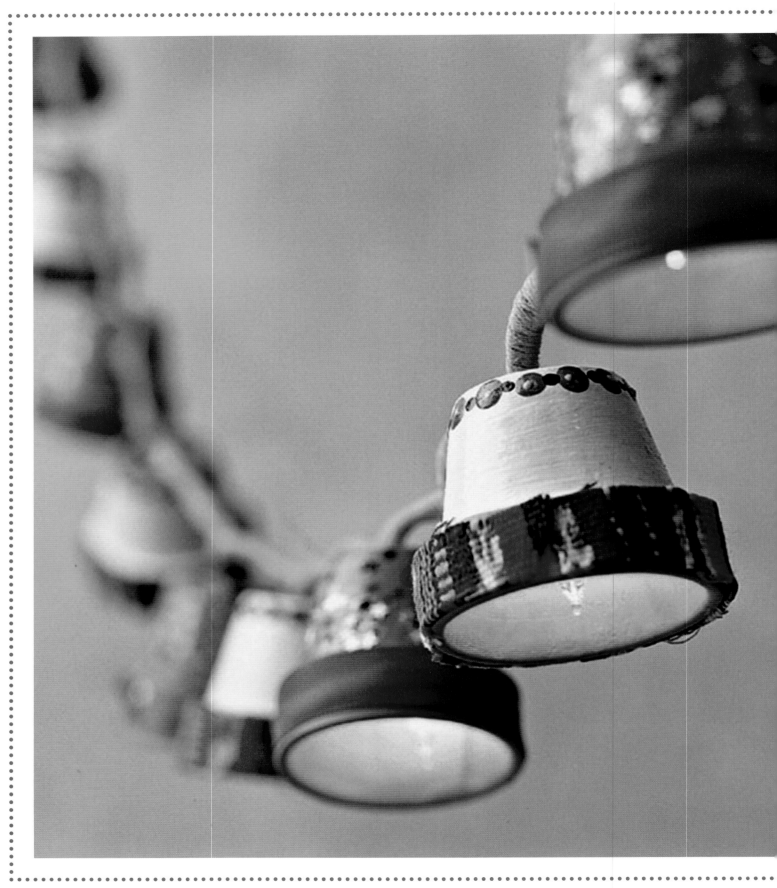

Mexicali mini-lights

Brighten up that outside patio! These days, you can find patio lights to match the wildest of themes. If pink flamingos, doll heads, or flying saucers don't light up your life, maybe these terra-cotta twinklers will. The combination of scrap ribbon, fabric, paint, glitter, and upside-down pots is all it takes to assemble awesome lights that are cool enough to rival any plastic manufactured set.

Makes one strand of lights

materials

- String of 12 white miniature lights
- 12 miniature terra-cotta pots, 2" (5 cm) each
- 1 yard (91.5 cm) of solid-color ribbon
- 1 yard (91.5 cm) of multicolored ribbon
- 2 packages of embroidery thread
- White acrylic craft paint
- Assorted paintbrushes
- Water-based polyurethane brush-on varnish, your choice of matte or gloss
- Star glitter
- White craft glue
- Hot glue gun and hot glue sticks
- Scissors

1. Turn all of the pots upside down. Paint six of them white on the main base and trim the rims with the multicolored ribbon using the hot glue gun.

2. Leave the remaining six pots unpainted, but attach the solid-color ribbon around the rims with hot glue. Brush a thin layer of white glue on the main base of each of these six pots and sprinkle the star glitter over it. Pat the star glitter in place with your fingertip.

3. Apply a coat of water-based varnish to the bases and tops of all the pots.

4. Cover the light cord by wrapping the embroidery thread around it from one end to another. Add a dab of hot glue to seal the ends.

5. Use a blade from the scissors to widen the hole at the top of each pot so a light will fit through it snugly. Attach the plastic casing of the light to the pot with hot glue for extra hold. Hang, plug in, and light.

VARIATIONS Cover the pots entirely in fabric or decoupage pictures on them. Add fringe around the rim instead of ribbon. Use a masonry bit to drill holes in the base of the pot for more light to shine through. Coordinate the lights to match your holiday décor and hang them on a tree.

 Tip Make sure to hang the lights low enough so that you can easily replace the bulbs. Always use caution when working with electrical objects. Read the directions on the package for safety measures.

Mucho monstera plant

Are you a plant parent in your heart but don't have a green thumb? It's okay, you're still a beautiful person! We'll just have to find a workaround until you're ready to try live plants.

Medium to large-size faux plants, like this monstera, can be found at discount stores and secondhand shops. Rather than leave it as is, give it an artsy makeover with paint and glitter and it will be the topic of conversation!

Makes one large faux plant

materials

Camera or smart phone

Medium-size monstera plant (or any large-leaf faux plant you can score)

Scissors

Assorted satin finish spray paint or acrylic craft paint

Water-based glitter brush-on varnish or water-based polyurethane spray varnish, your choice of matte or gloss

Assorted paintbrushes

Hot glue gun and hot glue sticks

1. Take a photo of the plant so you know where to replace the leaves after you remove them. Oftentimes with faux plants, the straight and curved stems are at different heights. You can also mark each leaf and its corresponding stem so you know where each one belongs.

2. Carefully remove the leaves from the stems by snipping them off cleanly with a pair of scissors. Paint both sides of each leaf with a white base coat. If using spray paint, spray each leaf in a well-ventilated area. Allow to dry thoroughly.

3. Paint each leaf a bright color. The leaves can be all different colors or different shades of the same hue.

 Make sure to paint the corresponding leaf stems the same colors and use a matching or neutral color for the main stem on the planter base.

4. For each leaf, mix a slightly darker color of that same hue by blending in a small amount of a complementary color or black paint and use it to outline the edges and veins. Let dry.

5. Brush on a coat of water-based glitter varnish or spray with water-based spray varnish in a well-ventilated area. Let dry.

6. Reattach the leaves back on their original stems by hot gluing them in place.

 Tip Use an acrylic paint marker to doodle on each leaf, or outline it, or write poetry or phrases.

8

Fiesta

Here's the basic recipe for a friendly fiesta:

- Comida (food)
- Mojitos, margaritas, rosé, or sangria—or *cafecito* (Cuban coffee)
- Musica (music)
- Amigas y familia (friends and family)

Combine these elements, add a dash of attitude, and mix with your favorite storytelling. Garnish with epic party favors and decorations.

Now that you have the correct formula, it's time to put it to use. Although the next few pages can't fulfill every aspect mentioned, they will definitely help set the mood. This chapter delves into the grand piñata that is party presentation.

What's the use of slaving over a hot stove all day if the table setting falls as flat as a deflated sopaipilla? Don't your enchanting enchiladas deserve better?

The art designs also extend beyond the edible. Therefore, you'll have to take that napkin from your lap and set it on the table—the craft table that is. You'll need it to wipe up any messy paint or glue spills that come from assembling some quirky Mexican wrestler place card holders.

Impressed? Wait until you see the delighted faces on your party guests when they arrive. It's then you'll realize that all the hard work was worth it, hot stove and all. Just keep one thing in mind—the key ingredient that pulls it all together is undiluted imagination.

And we all know you have plenty of that.

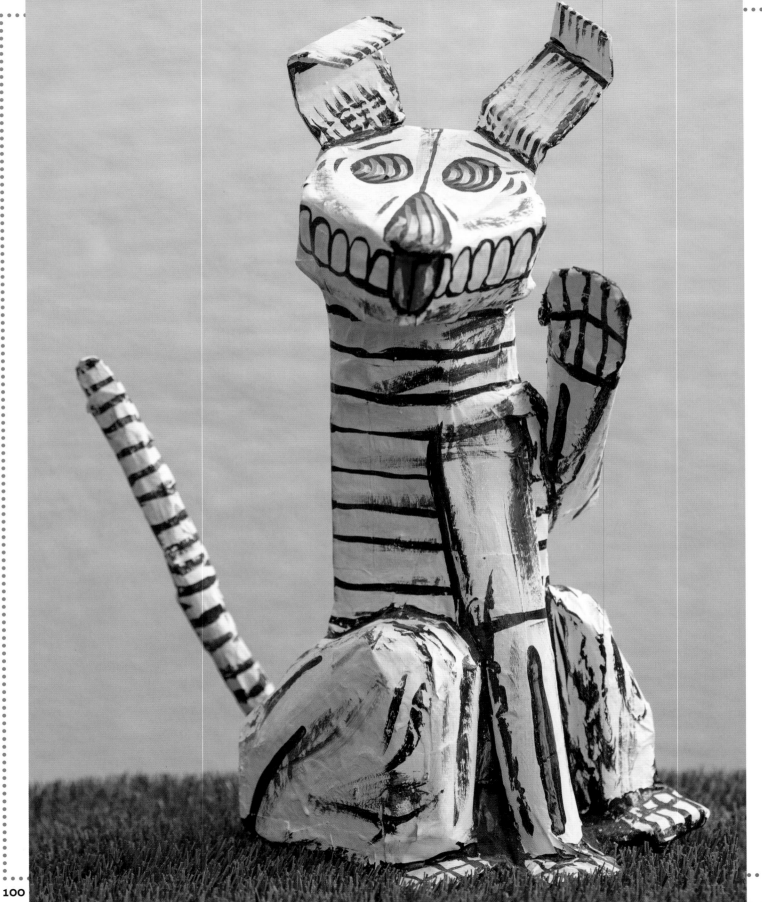

El perrito papier-mâché

When it comes to Día de los Muertos, decorations don't always have to be human skeletons—they can be animals too. If you are a pet owner who has had to say goodbye to a beloved pooch or kitty, this is a way to incorporate them into your *ofrenda* and *Día de los Muerto*s celebration of life. Create a papier-mâché sculpture in honor of them!

My husband, Patrick, made this after our dog Ozzy passed away. This piece is super cute, and it's our way of knowing Ozzy's spirit is alive and well in the afterlife.

Makes one sculpture

materials

- Large cardboard box
- 2 pieces of thin cardboard, 8" x 10" (20.5 cm x 25.5 cm)
- Masking tape
- Papier-mâché mix: 2 cups (250 g) of flour, 1 cup (235 ml) of water, and ¹/₂ cup (120 ml) of white craft glue or plaster wrap
- Hot glue gun and hot glue sticks
- Masking tape
- Acrylic craft paint in assorted colors
- Assorted paintbrushes
- Water-based polyurethane spray varnish, your choice of matte or gloss
- Floral foam
- Rubber tubing

1. Cut a 16" (40.5 cm) square from the cardboard box and connect the sides to create a long cone shape—this will be the dog's body. Tape in place with masking tape.

2. Create the hips by using floral foam cut into two squares. Use a knife to round off the tops. Attach to the body with hot glue. These will be the hind legs.

3. Take the two pieces of thin cardboard, roll each one into a tube, and use masking tape to secure in place. These are for the front legs. If you want one front leg up, bend it in half. Glue the front legs to the side of the body.

4. Cut four circles from the cardboard box to use as the paws. Attach one circle on each of the front legs and back legs using masking tape or hot glue.

5. Roll a long piece of rubber tubing for the tail and attach it to the back of the body.

6. For the head, cut two triangles of cardboard and a long strip to attach around the sides to join them together. Add two triangles for the ears.

7. Use papier-mâché or plaster wrap to cover the sculpture, following the manufacturer's directions. Let dry. Paint with white acrylic paint and then add accent colors and highlights. Let dry and then spray the entire piece with a coat of water-based spray varnish.

Glittery soda pop vases

On a dry, hot day, there is nothing more refreshing than an icy cold soda. This project is the ultimate homage to the many tasty Mexican carbonated beverages on the market. But it's not just the distinctive drinks that are appealing; their bottles are also a treasure. They are usually embossed, painted, and decorated to match the theme of the bubbly contents. Glitter not only intensifies this art, but also celebrates it.

Makes one vase

materials

- Empty Mexican soda pop bottle
- Assorted colors of dry microfine glitter with applicator tip
- Acrylic craft paint in assorted colors
- High-gloss water-based polyurethane spray varnish
- Assorted paintbrushes
- Toothpick
- Small dish

VARIATIONS This glitter-painting technique can be used on just about any surface. For a lighter look, use microfine glitter glue instead of paint.

1. Thoroughly wash and dry the bottle. Begin working from the inside of the design out. Squeeze the desired color of paint into a small dish. Dip the toothpick in the paint and carefully trace over the letters on the label. Quickly sprinkle the dry microfine glitter over the paint so it sticks. Touch up any areas that were missed. Continue the process of finishing the entire label in different colors of microfine glitter. For larger areas, use a liner brush. Let dry.

2. Repeat the process for the top of the bottle.

3. Cover the remaining and largest area of the bottle with a larger brush, working a section at a time.

4. Let dry and then look over the bottle for any bare spots. Fill in as needed.

5. Seal with a high-gloss water-based spray varnish. Let dry and then add your favorite flowers.

 Tip Use bottles that have the label painted or embossed on them, as opposed to paper labels.

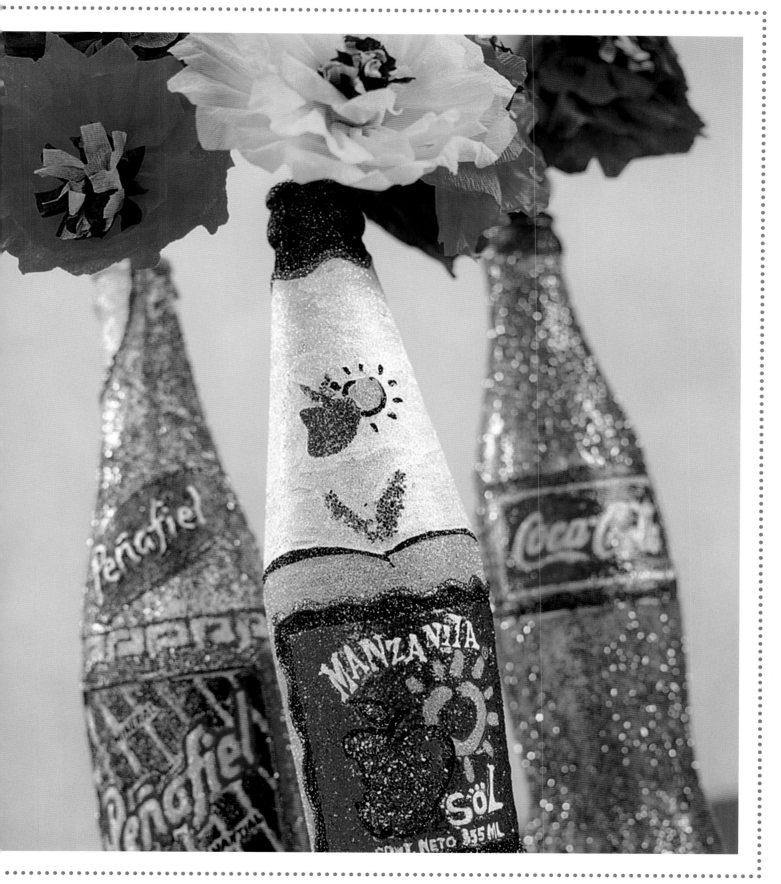

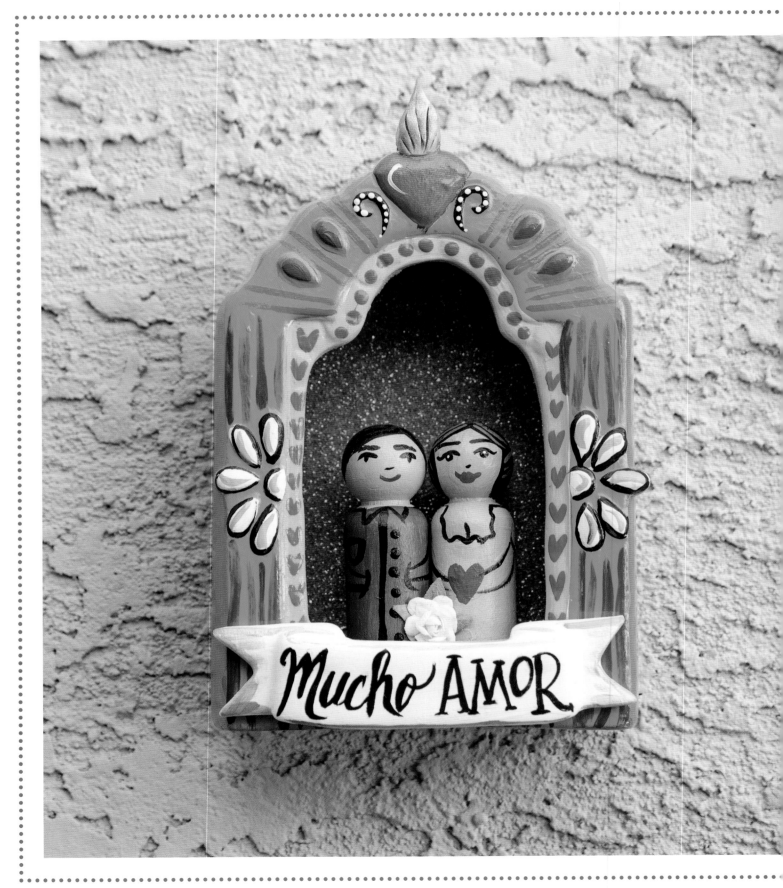

Mucho amor love shrine

It's always a good time to celebrate L-O-V-E. Companionship and romance isn't just for February, it's for every day of the year! Having sets and pairs of objects together brings good couple energy your way.

This art piece is simple but mighty. What makes it come alive are the hand-painted peg people you can customize to match your love interest. This project can be themed for friendship, romance, or even self-love. Love is love and it's time to celebrate!

Makes one art piece

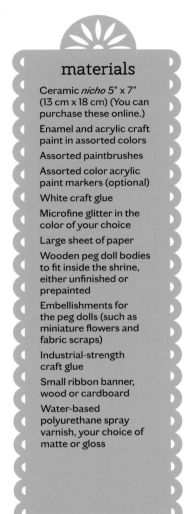

materials

- Ceramic *nicho* 5" x 7" (13 cm x 18 cm) (You can purchase these online.)
- Enamel and acrylic craft paint in assorted colors
- Assorted paintbrushes
- Assorted color acrylic paint markers (optional)
- White craft glue
- Microfine glitter in the color of your choice
- Large sheet of paper
- Wooden peg doll bodies to fit inside the shrine, either unfinished or prepainted
- Embellishments for the peg dolls (such as miniature flowers and fabric scraps)
- Industrial-strength craft glue
- Small ribbon banner, wood or cardboard
- Water-based polyurethane spray varnish, your choice of matte or gloss

1. Brush a base coat of enamel paint onto the nicho in your desired color or colors. Use various colors for the different sides to give it more character. I used bright colors and painted simple designs such as hearts, flowers, and lines. Allow the paint to dry thoroughly.

2. Brush on a layer of white glue over the entire inside of the *nicho*, except for the bottom where the peg dolls with be attached, and pour the microfine glitter over the wet glue. Collect any excess glitter on a large sheet of paper and return it to the jar.

3. Paint the peg dolls with your desired skin color using acrylic paint or turn them into Día de los Muertos figures. Add hair, clothing, and facial features using a liner brush or an acrylic paint marker for the fine details. If you don't want to paint the faces yourself, you can purchase prepainted peg dolls.

4. Decorate the peg dolls with embellishments such as mini-flowers or fabric clothing. Adhere them to the bottom of the nicho with industrial-strength glue.

5. Paint the ribbon banner using acrylic paint. You can add names, a special date, or a phrase. Adhere the ribbon banner to the front of the shrine with industrial-strength glue.

6. Spray the outside of the nicho with water-based spray varnish so it's nice and shiny. Use a permanent marker on the back of the shrine to journal about why you made the shrine. Why did you decide to make a love shrine? What kind of love are you craving? Friendship, family, or a juicy romance? Are you healing a broken corazón or looking for a new adventure?

VARIATION To make a smaller placemat or coaster set, use smaller paper or reduce the image on the copy machine.

Frida Kahlo fiesta placemats

It wasn't until after Frida Kahlo's death in 1954 that her art became appreciated worldwide—so much so, in fact, that she became an icon of Mexican culture. To this day, women of all ages and races adore this passionate and pained artist who was just as talented in the kitchen as she was in her studio.

These placemats pay homage to Frida and her flavorful recipes. Even if you can't tell a tortilla from a tamale, you can still have a bit of her energy and spirit at mealtime.

Makes one placemat

1. Arrange your images in an appealing fashion on the colored paper. Use large pictures as the focal points and add smaller items around them. Once you find a layout you are happy with, glue everything down with the glue stick.

2. Use the hot glue to add a trim of ribbon around the border of the paper, as well as an extended border of crepe paper.

3. At your local copy center, make a color copy of your finished design and have it laminated. Trim any excess, leaving a 1½" (4 cm) border. Store your original design in a safe place.

4. Punch holes along the short sides of the placemat and tie raffia tassels from each one.

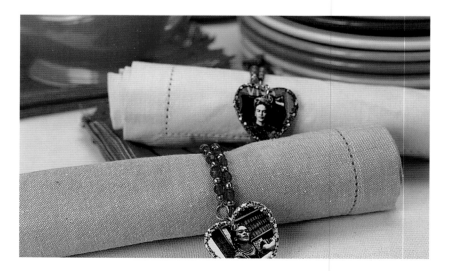

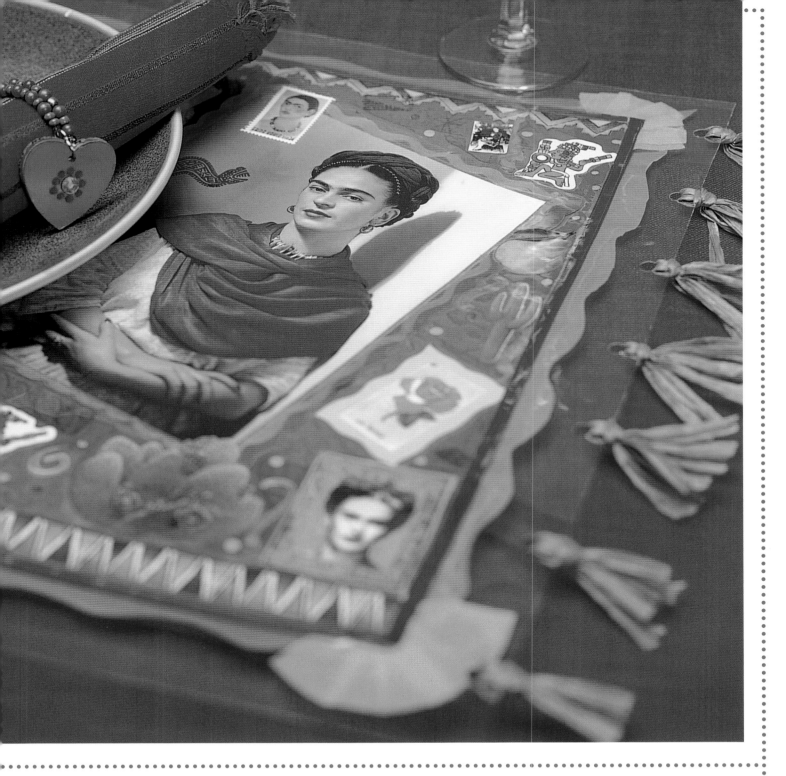

 Tip Make a set of placemats by making and laminating more color copies. By storing the original, you can make new placemats as needed.

Faux iced prayer candle

materials

- Whipped cream clay in assorted colors, with piping bags and piping tips (This is a delicate air-dry clay that looks like whipped cream and is used as faux icing on crafts.)
- Prayer candle (You can find these at many retail stores or online.)
- Paper towels
- Sketchbook or paper and pencil
- Scrap paper
- Miniature frame (to fit the candle) with a picture of your loved one
- Small letter beads
- Small clay skulls
- Miniature items that represent your loved one's personality
- Iridescent clear microfine glitter
- Tweezers

For those who honor *Día de los Muertos* on November 1 and 2, having a home altar or decorated gravesite is a must. On these days, it's believed that the spirits of our dearly departed loved ones return to their homes for one more family fiesta. Who can blame them? One of the main elements in decorating for this happy holiday is putting out a sweet offering of a *calaca* (sugar skull) adorned with swirls of brightly colored icing and dots of sequins.

Prayer candles are another important element when building an ofrenda, or altar. This project combines the best of both concepts—faux icing on the candle. This is a festive way to honor a loved one who has passed away by embedding a small picture frame at the front of the candle and inserting a small picture of the person the candle is intended for.

Makes one candle

1. Clean the candle with a paper towel so it's free of debris and fingerprints.

2. Sketch out a design of how you want to decorate your candle. Think about where you want to place the frame and embellishments.

3. If your whipped cream clay comes packaged in a piping bag and as part of a set, attach one of the piping tips that is included. If the whipped cream clay comes in a tub, transfer the desired amount into a designated pastry bag (or plastic bag) and attach a piping tip.

4. Do a test run of the piped icing on a scrap piece of paper and then apply the whipped cream clay to the entire candle, except the bottom, using the same method as if you were decorating a cake. I used the star tip to pipe little stars.

5. Set the candle on its base on a flat surface and ensure it is stable. Embed the small frame in the wet whipped cream clay.

6. Use tweezers to embed the letter beads, skulls, and any other small items according to your design into the wet clay.

7. Sprinkle iridescent glitter over the still wet clay for a shimmery effect. Collect any extra glitter on a sheet of paper and place it back into the jar.

8. Allow the clay to dry thoroughly, which may take several hours.

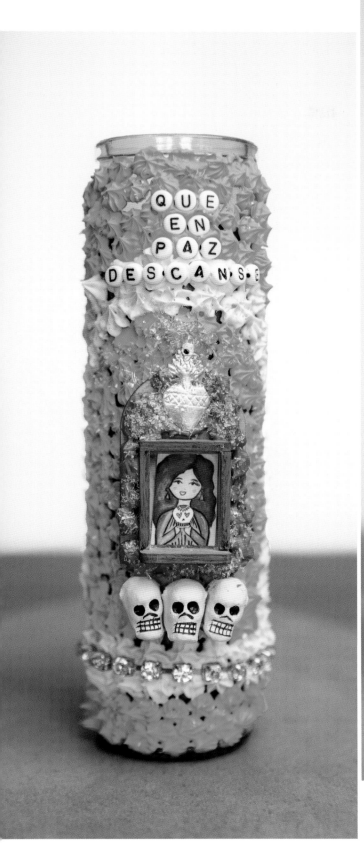

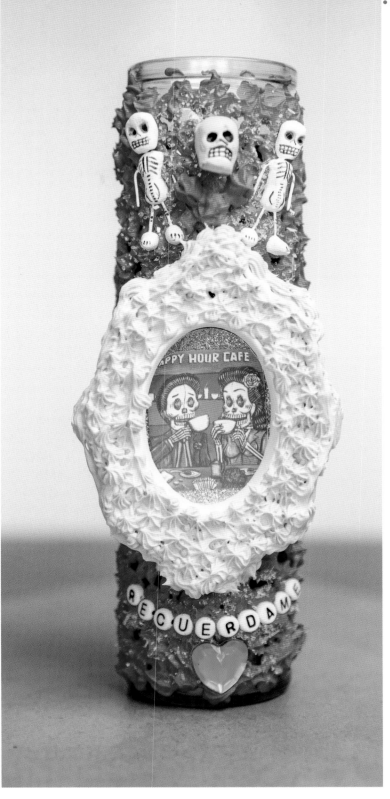

Hot, hot, hot! chips and salsa set

VARIATIONS Use other types of planters for the middle. Make smaller sets for smaller tables.

A fiesta without chips and salsa is like a *piñata* without candy. Never underestimate the conversational power of warm and crispy corn chips accompanied by juicy, salty, and searing salsa. Honor this timeless tradition by delivering the spicy goods with *mucho* flavor and character. This ordinary terra-cotta saucer and planter set goes above and beyond its normal course of garden duty to become a dazzling centerpiece that screams hot, hot, hot!

Makes one serving set

1. Paint the entire surface of the saucer, planter, and wooden balls with the acrylic paint. Add detailed designs, as desired.

2. Use industrial-strength glue to adhere the wooden balls in a triangle pattern to the bottom of the saucer and the glass pebbles to the bottom of the planter.

3. Use a foam craft brush to apply several layers of water-based varnish to the planter and saucer. Let dry in between coats and wait 24 hours before using. Insert the glass bowl into the planter.

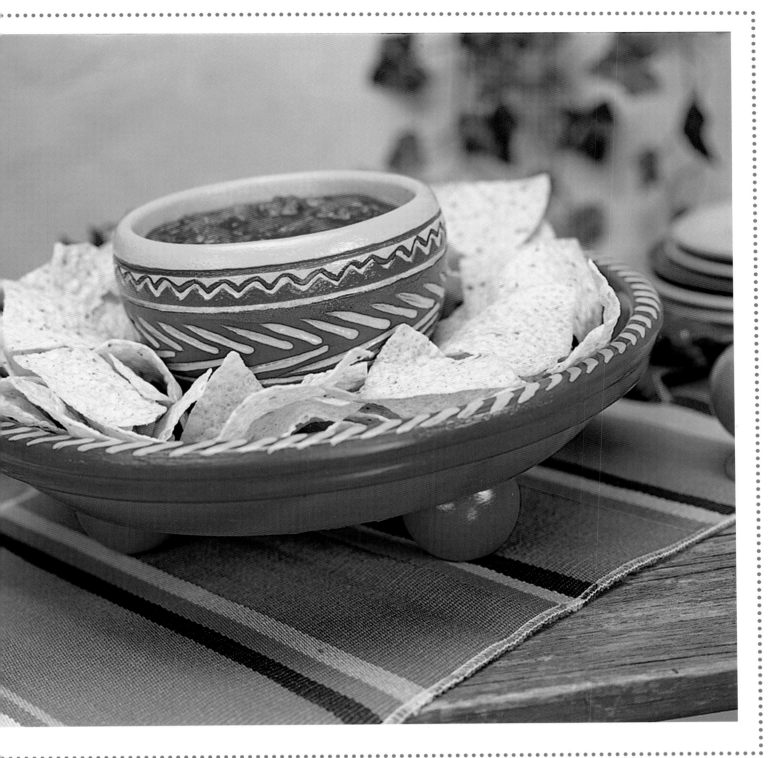

 Tip To clean the saucer and planter after using, gently wipe the surfaces with a damp cloth. Occasionally revarnish both the planter and the saucer to keep them looking new.

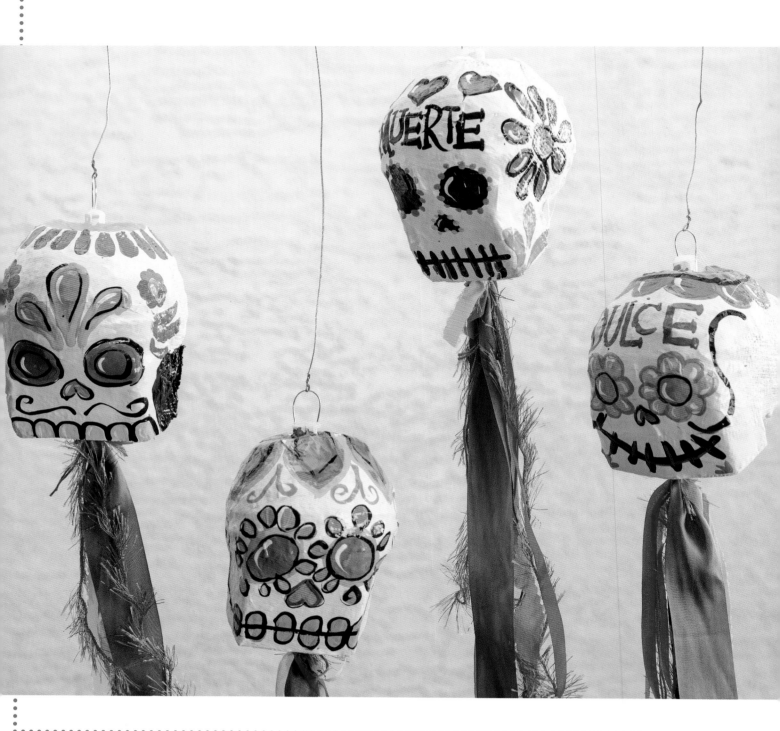

Tip For cooler climates, drying time for the papier-mâché may be longer. Also, don't be disappointed if your skull comes out looking less than perfect. The beauty of this project is that each one is unique.

Papier-mâché skull ornaments

Papier-mâché skulls are displayed everywhere for Día de los Muertos. They last a long time and are so festive to decorate. The skulls are often used on ofrendas (altars) or in art exhibits because they can be left out, unlike real sugar skulls that will degrade over time.

This idea is a twist on tradition. Rather than make the calacas and set them on an ofrenda, you can hang them. Hang them on a patio porch, from the ceiling, from your car, or wherever you want to add charm.

Makes one skull ornament

1. Open the lantern and insert the structure form inside, so it is round and three dimensional.

2. Wrap the mini lantern with masking tape to create the sides of the skull. It should look flat on the sides and round on the front and back to resemble a skull.

3. Tape the cardboard piece to the bottom front of the *calaca*. Make sure it is securely attached.

4. Mix the papier-mâché ingredients in a glass bowl to a thin pancake-batter consistency. Add extra water or glue if necessary. Tear newspaper or magazine pages into strips measuring approximately 2" (5 cm) wide.

5. Apply the strips all over the lantern, creating one layer. Leave the paper lantern's top hanging attachment intact. Allow the strips to dry thoroughly.

6. Apply a second coat of papier-mâché strips. Let dry overnight and then brush on a base coat of white acrylic paint or any other color you choose. Let dry and then use black paint and a liner brush to create the eye sockets, an upside-down heart for the nose, teeth, and cheek bones.

7. Paint on brightly colored embellishments to the face features: fill in the eyes with color, add painted flowers, etc. If desired, use a liner brush or an acrylic paint marker to write a name on the forehead and add flowers or polka dots using dimensional fabric paint. Then, sprinkle on glitter or press in gems before the dimensional paint dries. Brush on a layer of water-based varnish to complete.

8. Tie the ribbon pieces in a knot at one end and hot glue the knot to the bottom of the *calaca*. Add string through the hanging attachment and hang for your fiesta.

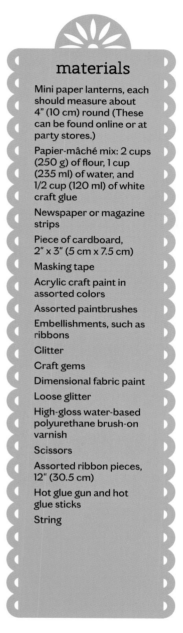

materials

- Mini paper lanterns, each should measure about 4" (10 cm) round (These can be found online or at party stores.)
- Papier-mâché mix: 2 cups (250 g) of flour, 1 cup (235 ml) of water, and 1/2 cup (120 ml) of white craft glue
- Newspaper or magazine strips
- Piece of cardboard, 2" x 3" (5 cm x 7.5 cm)
- Masking tape
- Acrylic craft paint in assorted colors
- Assorted paintbrushes
- Embellishments, such as ribbons
- Glitter
- Craft gems
- Dimensional fabric paint
- Loose glitter
- High-gloss water-based polyurethane brush-on varnish
- Scissors
- Assorted ribbon pieces, 12" (30.5 cm)
- Hot glue gun and hot glue sticks
- String

VARIATIONS Adjust the size of your skulls by using different-sized paper lanterns. Have fun by adding false eyelashes, earrings, flowers, or a hat to your *calaca*.

Lucha libre place card holders

America has The Rock, but Mexico has El Santo. We're talking wrestling rings and mano y mano combat. Lucha Libre (Mexican wrestling) is a wildly popular South-of-the-Border sport that was launched during the 1930s and has spread worldwide. With names such as El Santo, Mil Mascaras, and the Blue Demon, these theatrical characters donned ornate and flamboyant costumes that represented a personalized theme. Their style combined the elements of wicked wrestling, circus acrobats, and outlandish audience confrontations. It wasn't long before the success of Lucha Libre spilled over into the arena of the Mexican cinema. These muscled masked men suddenly became more than fighters in a ring; they became cultural icons and superheroes for *la gente* (the people). Add a bit of that Lucha Libre power to your next party table setting by creating these place card holders that really pack a punch.

Makes one place card holder

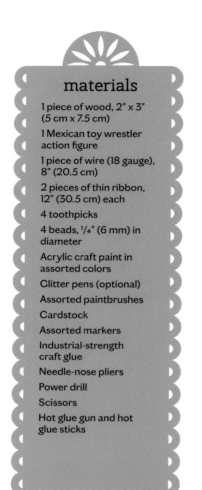

materials

- 1 piece of wood, 2" x 3" (5 cm x 7.5 cm)
- 1 Mexican toy wrestler action figure
- 1 piece of wire (18 gauge), 8" (20.5 cm)
- 2 pieces of thin ribbon, 12" (30.5 cm) each
- 4 toothpicks
- 4 beads, ¼" (6 mm) in diameter
- Acrylic craft paint in assorted colors
- Glitter pens (optional)
- Assorted paintbrushes
- Cardstock
- Assorted markers
- Industrial-strength craft glue
- Needle-nose pliers
- Power drill
- Scissors
- Hot glue gun and hot glue sticks

1. Drill a hole at each corner of the wood. Snip the pointy ends off of the toothpicks, add a small dollop of industrial-strength glue to one end, and insert them into the holes. Paint the wooden base and the toothpicks and let dry.

2. Tie one of the ribbon strands to the bottom of one of the toothpicks. Wrap the ribbon around the other toothpicks to create the look of wrestling ring ropes. Repeat the process for the upper ropes and tie off the ribbon.

3. Decorate the action figure with paint or glitter pens, let dry, and then glue him slightly off-center in the ring using industrial-strength glue.

4. Use the needle-nose pliers to create a spiral at the end of the wire. Drill a hole into the wooden base near the feet of the action figure. Add a dollop of hot glue to the wire and insert it into the hole.

5. Use hot glue to attach the beads on the bottom of the base to act as feet. Decorate the place card with markers and insert it into the standing spiral.

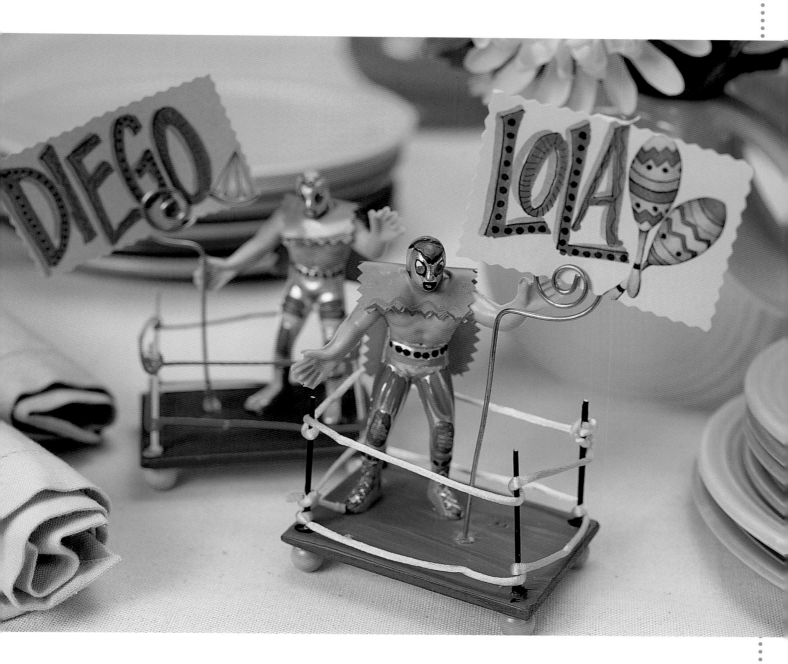

VARIATIONS Make your place setting an equal opportunity one. Transform the male wrestlers into female ones by adding long hair and skirts. For an interactive party game, have your guests make up Mexican wrestler names for each other and write them on the back of the place cards.

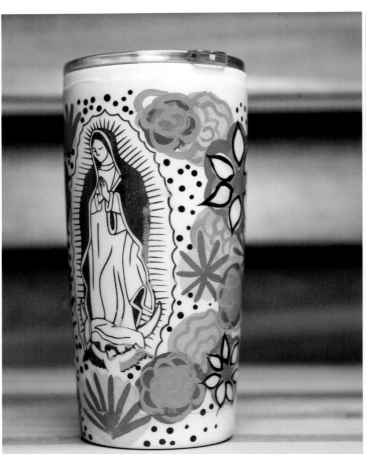
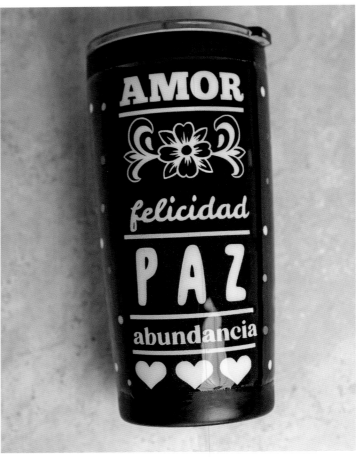

Hand-painted Mexi-tumblers

These tumblers make every sip memorable. If you've always wanted to try making resin tumblers, now is the time. Most resin tumblers have vinyl cut-out designs and look fabulous, but let's be super crafty by taking it a step further and adding some hand-painted accents.

Create a batch to give as gifts, party favors, prizes, or to make everyone at your fiesta feel special. If you're throwing a birthday party, create a stencil design of the person you're celebrating and spray paint it on the cup. There are so many ideas!

Makes one tumbler

1. Sketch your design on paper to use as a guide.

2. Adhere the electrical tape around the top edge of the tumbler. This will prevent the lips from touching the paint. Also add it to the bottom.

3. Spray paint the tumbler, one thin coat at a time. Two coats should cover it nicely.

4. Create a vinyl design for the centerpiece of the tumbler either using an electronic cutting machine or cutting it by hand. If using an electronic cutter, follow the manufacturer's directions. I did a combination of words and designs. Alternatively, hand paint a design using acrylic paint and brushes. You can also create a design by taping on a stencil and spray painting or using acrylic paint and a stencil brush.

5. Paint on your artwork around the vinyl or stenciled design using a variety of craft paints. You can create lettering or flowers or even portraits. Allow the paint to dry thoroughly. Brush on white glue and sprinkle microfine glitter over accent areas if desired.

6. Now it's time to resin the tumbler using the cup turner. Set up the turner on a tabletop in a spot that is free of debris and insects and is well ventilated. Cover the tabletop with wax paper and set the cup turned on top. Insert the tumbler on the turner and turn it on to make sure it rotates properly.

7. Put on the protective gloves and a mask.

8. Follow the epoxy manufacturer's instructions to mix the two-part resin in a plastic cup, using 1/2 ounce (15 g) of each (most two-part resins are mixed in a 1:1 ratio).

9. Stir thoroughly, but not vigorously, so as not to produce air bubbles. If air bubbles appear, use a heat gun to pop them—glide the heat gun over the surface of the wet epoxy. Once the epoxy is mixed, let it sit for five minutes.

10. Turn on the cup turner so the tumbler rotates at a pace quickly enough for you to add the epoxy, but not so slow that the epoxy drips off.

11. While still wearing the gloves, slowly pour a portion of the epoxy approximately the size of a fifty-cent piece over the tumbler, using your fingers to smooth it all over the cup. Make sure your designs are covered evenly from top to bottom. The cup turner will be rotating slowly, giving you proper time to smooth the epoxy over the tumbler's surface.

12. Let the cup turner continue to rotate (check on it every 30 minutes or so) for a couple of hours until the epoxy has hardened enough that it won't slide off but is still soft. Carefully remove the electrical tape. Do this before the tumbler is fully hardened; otherwise, it won't come off. Let the tumbler keep turning until fully cured.

materials

- Stainless steel tumbler
- Paper and pencil
- Satin finish spray paint
- Two-part epoxy
- Acrylic craft paint in assorted colors
- Assorted paintbrushes
- Vinyl cut-out decals (You can find these at craft stores or purchase online.)
- Electrical tape, 1/2" (6 mm) wide
- Motorized cup turner (found in craft stores or online)
- Wax paper
- Protective gloves and mask

Tips

- Work in a well-ventilated area, preferable outside or in a garage or a room with an open window.
- Keep checking on your cup turner to make sure it doesn't get stuck or have any issues. If you accidentally smudge your epoxy on the tumbler, just let it keep turning; it will eventually self-level.

The following templates can be used to make several of the projects found in this book. Feel free to use these images for projects of your own. They can be enlarged or reduced on a copy machine to fit your design.

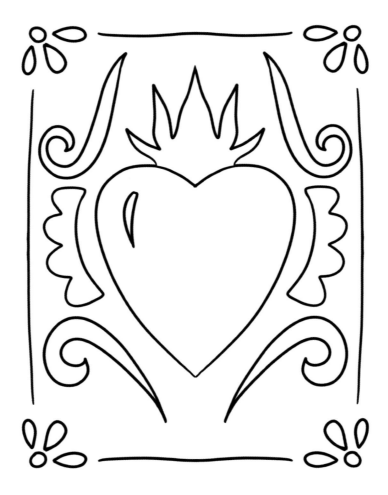

Dicho Template for the Repujado Dicho Matchboxes (page 34)

Angel Template for the Chichana Love Wall Tapestry (page 48)

Mermaid Template for the Sirena Corda Pillow (page 54)

inhala

exhala

Text Template for the Inhala, Exhala Sign (page 58)

Sacred Heart Template for the Terra-Cotta Sacred Heart (page 90)

Resources

The Crafty Chica
Ceramic bisque pieces, scrapbook papers, stickers, art
craftychica.com

Cricut
Electronic cutting machine and supplies
cricut.com

Jenny Lorenzo
T-shirts
jennylorenzo.com

Mexican Arts Imports
Assorted authentic art from Mexico
mexicanartsimports.com

Mucho Mas Art Studio
Papers, stamps, stickers, appliques
muchomasartstudio.com

Oilcloth International Inc.
Oilcloth
oilcloth.com

Que Rico T-Shirt Co.
Apparel, buttons, pillows, and more.
quericotees.com

Sew Bonita
Fabrics galore
sewbonita.com

Te Lo Juro Collective
Fashion and art
telojurocollective.com

The Crafty Chica Store
Official store
craftychicastore.com

Upstart Epoxy
Epoxy resin
upstartepoxy.com

We R Memory Keepers
The Cinch bookbinder
wermemorykeepers.com

Acknowledgments

Thank you so much to the Quarry Books team, my editor Jeannine Stein, and my very first editor, Mary Ann Hall! Thank you for believing in the magic that I aim to share with the Crafty Chica brand. My first book, *Making Shadow Boxes and Shrines* helped launched my career in the craft world and I am forever grateful.

Mucho love with all my heart to my husband, Patrick, and my kids, DeAngelo and Maya, and my sister Theresa for always being there to support and help. And *gracias* to friends Candy Olivares, Eliana Murillo, Alexa Westerfield, Luisa Leon, and Curtis Parhams for being on call 24/7 to help me with design choices for the projects when I couldn't decide; to Emily Costello for running our beloved Mucho Mas Art Studio while I stayed home to finish this book; Carla Chavarria and Alejandro Larios from La Bohemia for the delicious Cafecito; Genaro Delgadillo for taking the beautiful pictures; Meagan Mora for modeling; and the happy energy they all shared with me!

Most of all, thanks to all of you! Thank you for sticking with me on this fantastic journey of art and craft and celebrating our *cultura*! I truly hope you love this book. Please connect with me and let me know! Email me at info@craftychica.com. I'd love to hear from you!

About the Author

Kathy Cano-Murillo, The Crafty Chica, is a former syndicated newspaper columnist for *The Arizona Republic* and now a full-time creativepreneur. This is her eighth craft book, and she has also authored two novels, *Waking Up in the Land of Glitter* and *Miss Scarlet's School of Patternless Sewing*. Kathy's most recent book is *Forever Frida: A Celebration of the Life, Art, Loves, Words, and Style of Frida Kahlo* Kathy has several Crafty Chica product lines including greeting cards, paper crafting supplies, ceramic bisque pieces, and two fabric collections. She has been featured in *Forbes*, *The New York Times*, *Buzzfeed*, and more. Visit Kathy at craftychica.com or at the on social media @craftychica. She is a wife and a mom of two kids and three Chihuahuas!

Index